BEYOND REALISM

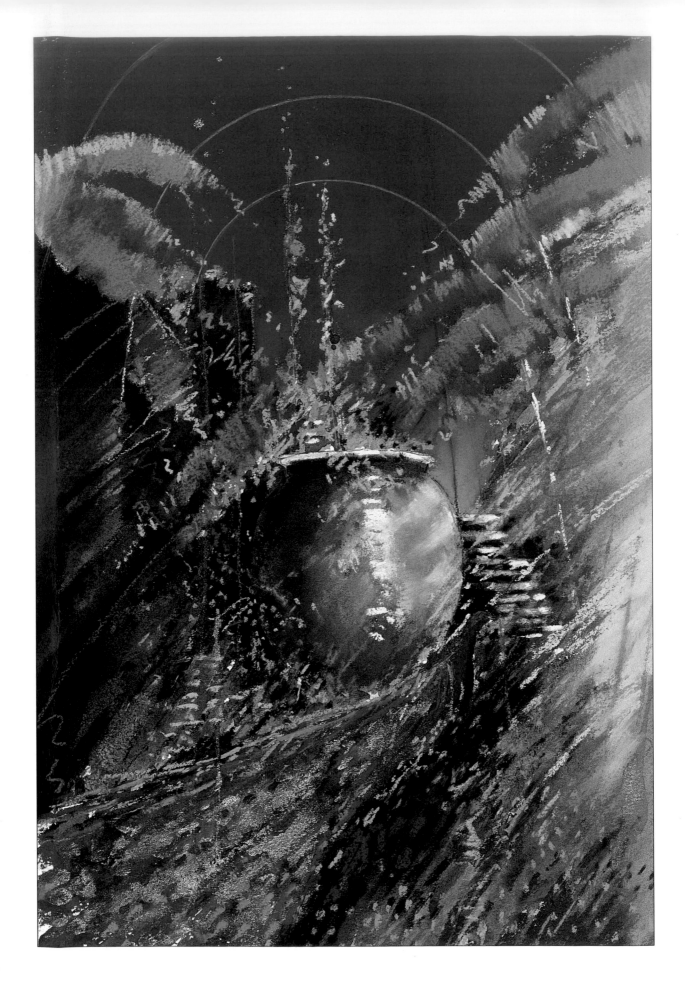

BEYOND REALISM

art techniques to expand your creativity

BRIAN RYDER

David & Charles

(page 2) ***Urn and Peacock***

DEDICATION

I dedicate this book to Linda, whose belief in my work has never wavered. This book is the result of her support and encouragement throughout the years.

A DAVID & CHARLES BOOK

First published in the UK in 2001

A catalogue record for this book is available from the British Library.

ISBN 0 7153 1165 4

Printed in Hong Kong by Dai Nippon
for David & Charles
Brunel House Newton Abbot Devon

Publishing Manager Miranda Spicer
Commissioning Editor Sarah Hoggett
Art Editor Diana Dummet
Desk Editor Freya Dangerfield
Copy Editor Ian Kearey
Design Sue Rose
Picture Research Alison Wilson

Publisher's note: it is strongly recommended to work in a well ventilated area when using oil paints and solvents, and when using soft pastels to avoid inhaling pastel dust.

Contents

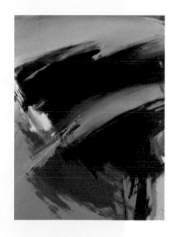

Introduction

I have been painting now for about 35 years, and I am as excited by the process now as I was when I started. As with so many things in life, one never stops learning; and the process of development is, for me, a life-long journey on which I embarked all those years ago.

I now paint in all media, sometimes in just one, sometimes mixed – it doesn't matter really, as the medium changes to suit my feelings at the time. This was not the case when I began painting all those years ago. Then I painted exclusively in oil, and I am certain this was due to the many visits I made to the National Gallery when I was working in London. It was the scale and power of Turner's oil paintings which really impressed me and, I suppose, as a result, oil was a natural choice for me to make.

The more I painted the more I began to realize that what separated the really great painters from the not so great was not so much their ability or skill in actually

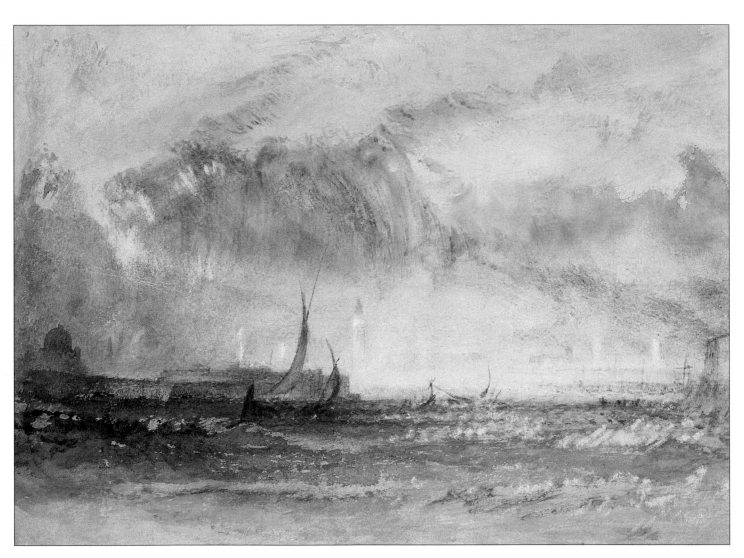

J.M.W. Turner (1775–1851) *Venice, Storm at Sunset 1840–42*

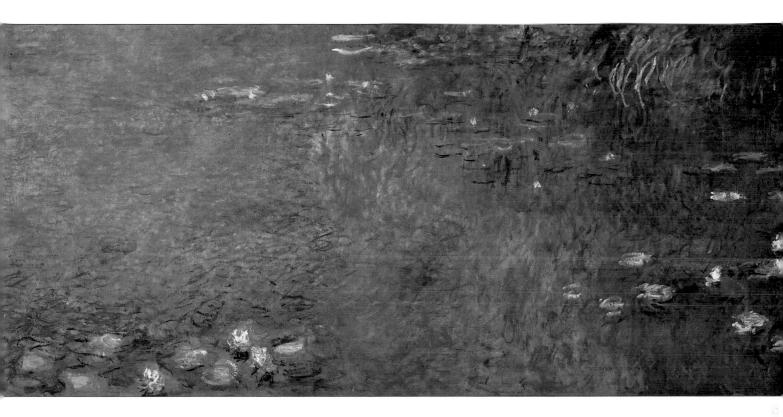

Claude Monet (1840-1926) Water Lilies

applying the paint to a surface, although there is no doubt that skill and technique are important in this respect; for me, what separates the really great painters from the others, however good they might be technically, is the sheer scope of their imagination.

Painting is a wonderfully creative means of communication. We know that our cave-dwelling ancestors were able to express themselves in simple line drawings, and these tell us about the key elements in their lives and what was important to them and to their survival. From this 'primitive' beginning painters have recorded and reflected contemporary life throughout the ages, and have provided a valuable insight into how they lived and what shaped their lives at the time.

This was largely true until the early part of the nineteenth century, when Turner began to produce his wonderful, atmospheric paintings on a grand scale. To begin with, Turner's contemporaries and the establishment gave little credence to the new work he was doing, in spite of his enviable reputation and the high profile he enjoyed at the time.

The painting shown here is a superb example of his skill in portraying atmosphere in his paintings; in this case a sunset. In my view, it is very likely that he chose the subject to support the atmosphere he wanted to create, rather than as a central theme in its own right. Towards the end of his career, much of Turner's work relied more on his wonderful use of colour to convey atmosphere rather than topographical details.

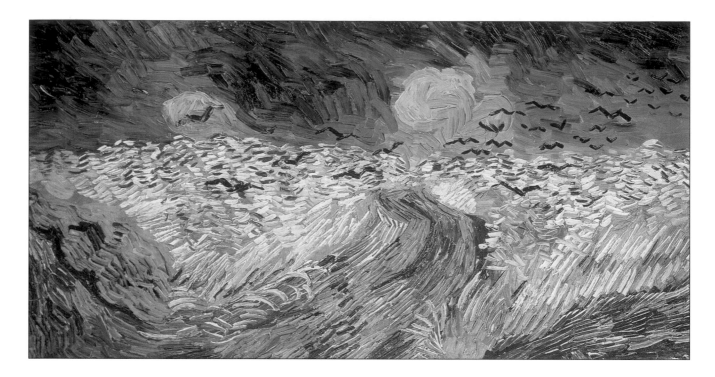

Vincent Van Gogh (1853–90) *Wheatfield with Crows*

Turner's paintings greatly influenced a group of French painters visiting London a few years later, amongst them Claude Monet. Upon returning to Paris they held a number of exhibitions and, as a group, they were referred to as the Impressionists.

Monet is perhaps best known for his series of water-lily paintings, and whilst the one I have chosen to show here is not his most famous, it is nonetheless typical of the style he often used. We are invited to take part in the painting by completing much of the detail for ourselves. The subject emerges out of the marks of overlaid strokes of colour with a hint of the complementary red shining through.

Vincent Van Gogh, by contrast, painted exactly what he wanted us to see, often using very bright strokes of colour with an impasto technique. Setting strong bright blues against yellows, he acknowledged actual colours in their brightest sense seen under sunny skies. This style, perhaps the one most commonly associated with Van Gogh, was a distinct contrast from his early, much more traditional work. His brushwork here is energetic, and the paint is applied with exuberance and verve; the result is vibrant and exciting.

Many of the paintings by Willem de Kooning demonstrate the sheer delight of an 'Expressionist-Impressionist' style. What initially appear to be bold, almost childlike splashes of colour reveal, on closer and more considered inspection, a very thoughtful composition of colour and form, applied with verve – and a large brush. I cannot help but feel a link in de Kooning's painitngs with Van Gogh and, to some extent, Turner's approach, where detail is suggested with overlays of colour, particularly within larger areas of flat colour.

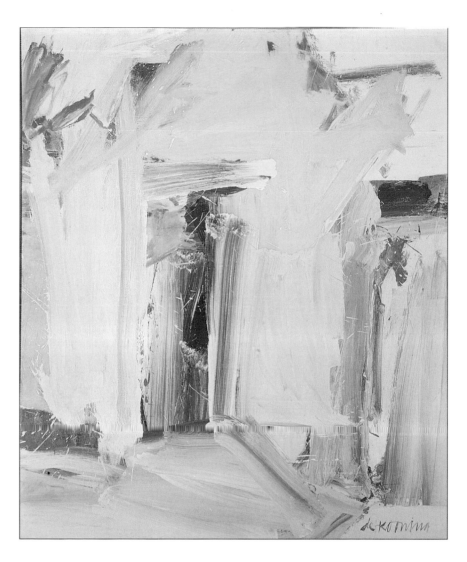

Willem de Kooning (1904–97) *Door to the River*

The paintings that are illustrated here are, of course, examples of work by painters I admire. Naturally there were many others I would have wished to include – notably Raoul Dufy, Mark Rothko, Peter Lanyon and Howard Hodgkin, all of whose work I feel has had an influence on my own approach – but the space available would not permit this, so I have had to be very selective indeed. I hope, however, that I have been able to provide a glimpse of the variety of work which could be collectively entitled 'Beyond Realism'.

I have deliberately avoided any theorizing, and to this end would like to declare my allegiance to the 'enjoy it and have fun' brigade and distance myself from those who tend to perhaps over-intellectualize. In my view, the way to enjoy art, abstract or otherwise, is to stop looking for hidden depths or meaning and simply – and above all else – to enjoy it.

A Personal Gallery

The following small 'gallery' of my paintings is intended to show how the study of modern masters has influenced my own work, both technically and as an emotional response. However far you decide to go beyond realism, and in whatever style, the more you experiment and use different media, the more choices you will have for your own personal interpretations.

In addition to examining various styles, techniques and approaches to painting in an abstract and semi-abstract way, my intention in writing this book was to share some ideas as to how my paintings are constructed, and some of the thought processes and influences behind each one.

The notes that accompany each painting in the small selection on the next few pages give some indications of my approach; and the step-by-step projects in the next section include further suggestions and examples which, I hope, you can find useful as part of the process of developing your own work.

Blues Then Pink
Acrylic on canvas
101 x 76cm (40 x 30in)

This is one of my own favourite paintings – a pure abstract that was painted for pure enjoyment, hence no actual subject-related title. Shades of the St Ives school, perhaps, with soft, pale colours.

Red River
Acrylic on canvas
101 x 71cm (40 x 28in)

This painting is reminiscent of a loose Rothko, if more powerful and less ethereal. Although pure Expressionist abstract, where no subject matter was used when I started, the result reminds me of a gushing river with spray on rocks. It was fun to paint, and I was pleased with the result.

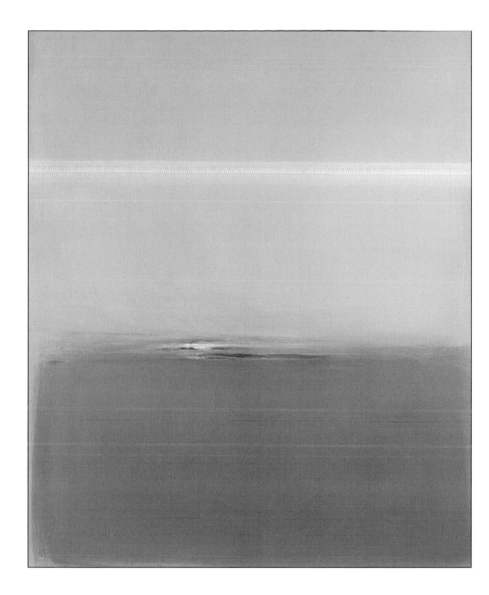

Scolt Head
Acrylic on canvas
76 x 91.5cm (30 x 36in)

The setting sun on a bird sanctuary in the twilight. I find hints of Turner and Rothko here. The more you look, the more you see.

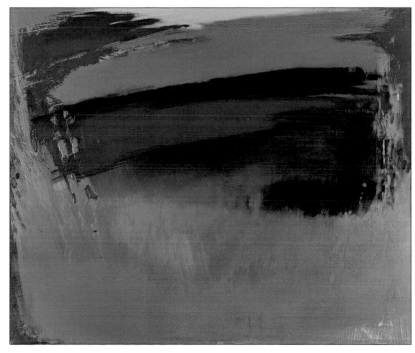

Poppies
Acrylic on canvas
50 x 60cm (19.5 x 25in)

The use of vibrant complimentary colours in this painting made it an ideal choice to create the visual impact required for the jacket of this book.

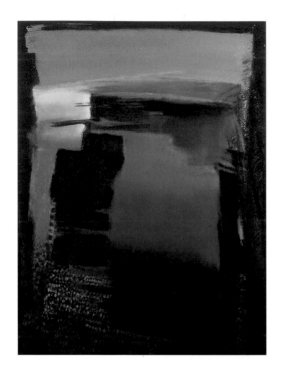

All or Nothing

Acrylic, oil and oil pastel on canvas
101 x 76cm (40 x 30in)

Lots of colours used on a painting with
no central theme – hence the title.
A slice of English landscape, with its
rives, fields and meadows of poppies
and rapeseed. The azure skies hint of
summer. A riot of colour and texture.

Black on Blue

Acrylic on canvas
101 x 76cm (40 x 30in)

Lacking a title for months,
this is a pure abstract so
I stopped looking for
something in it. Shades
of *Blues Then Pink*, but
more powerful.

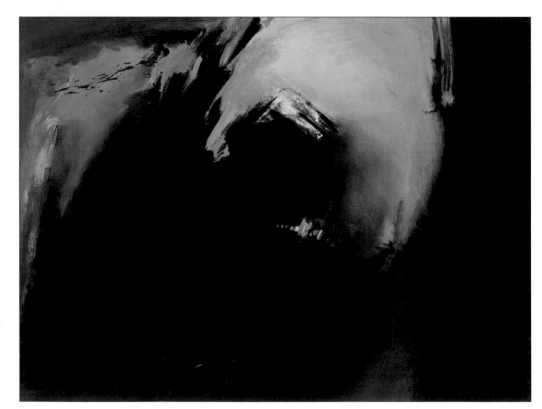

Still Waters
Acrylic and oil pastel on canvas
101 x 76cm (40 x 30in)

A lake or foreshore with a hint of land in the distance. My focal point of bright luminosity was placed running off the bottom edge, with soft, Rothko-type overlays in the central area. An unusual composition, but I think it works.

Pastureland
Oil and acrylic on canvas
61 x 53.5cm (24 x 20in)

A field of poppies often seen in my area of the countryside. It is known as 'poppyland', and I just changed it to *Pastureland*. A *mélanqe* of complementary colours.

Adventurous Painting Techniques

The techniques explored in this section are not the standard 'how to apply paint' methods you may find in other practical art books. Because the way in which you approach abstract or beyond-realist art is very much a personal response to your subject matter, what is explained here is how I use certain more advanced techniques to achieve effective results. In the projects, there are cross-references to the techniques at the bottom of the relevant pages.

Painting Acrylic Washes

Acrylic paints are ideal for large abstract paintings, because they dry quickly and you can overlay paint without the waiting time needed with oils. To apply a base, dilute the paint as much as you like and then spread the wash. I like to show the brushstrokes and the direction, and to make thick and thin areas.

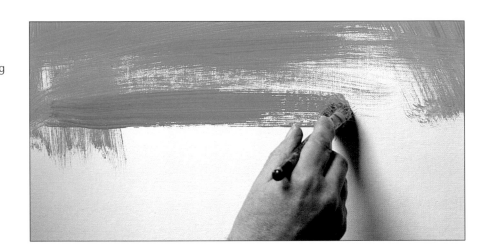

Removing Acrylic Paint

Step 1

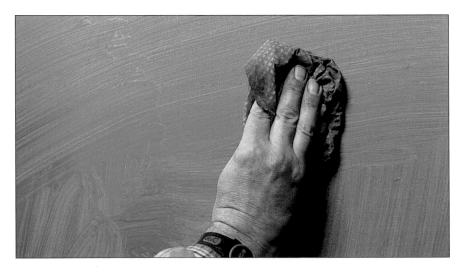

Allow the wash to dry for about a minute. Wipe a damp cloth – not too wet – across the wash, unifying the colour as you go by pulling and rubbing it into the canvas.

Step 2

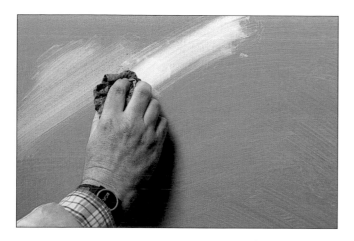

Step 3

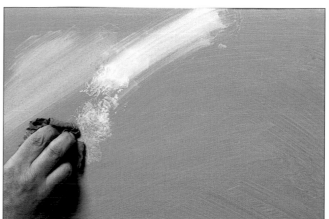

To remove even more paint, allow the wash to dry until it is just damp to the touch, then damp the cloth again and wipe or rub it across the area. It's similar to using an eraser to create highlights in a pencil drawing, and you have the choice of leaving the removed area or covering it later.

One way I use to get more random, broken effects is to damp a cloth and then dab it on the almost dry paint, using different pressures. Keep rearranging the cloth so that you use a clean face each time.

Blending Acrylic Paint

Step 1

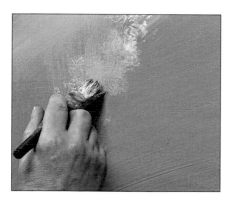

Step 2

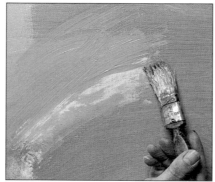

Step 3

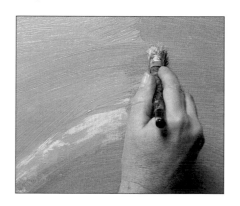

Allow the first wash of paint to dry, then load a brush with another colour, wipe the paint off until the brush is almost dry, and blend the new layer over the first one. Here, you can still see the area that was dabbed off earlier.

To show the difference between using a dry brush and a more loaded one, I added another yellow on top of the first wash, leaving it unblended at this stage.

Use very light strokes – hardly touching the paint – to blend the two yellow layers together on top of the first layer. You can also choose which parts of the latest wash you wish to blend and soften, and which to leave as more solid areas.

Creating Acrylic Textures

Step 1

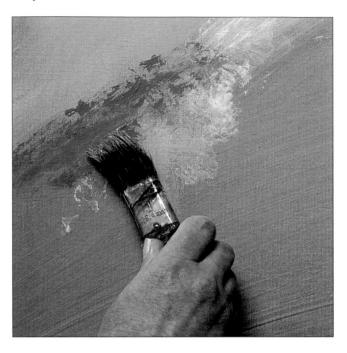

Step 2

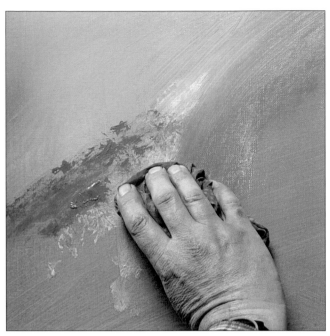

One way to build up textures and effects in acrylics is to use two colours on the same brush. Squeeze out equal amounts of the colours into a mixing bowl or onto your palette, then carefully load the brush and gently apply it. I used purple and the green from the first wash.

While these colours are still wet, use a slightly damp cloth to pull them over the underlayers. This both blends them and gives them a directional sweep, and the result is an effect that is both fragmented and solid, from using undiluted paint.

Step 3

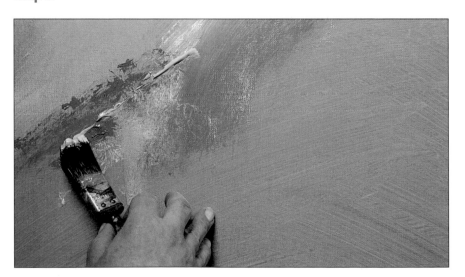

To produce an impasto effect over this, load the next colour thickly onto the brush and then just lightly touch it onto the surface. The yellow line follows the sweep and direction of the blended purple.

Painting with Oils

Step 1

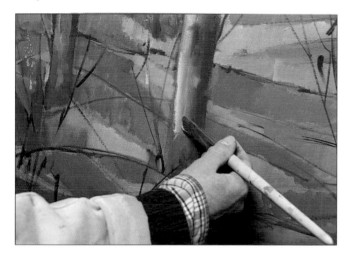

This shows a method of blending colours on the canvas, not on the palette. Squeeze out two colours right next to each other, then load the brush with one colour on each half and apply it. Here, the white paint creates a highlight for the green, and lightens the tone of the tree trunk.

Step 2

While the green and white layer was still very wet, I straightaway loaded some blue onto the same brush and applied it over the blended colours. This further blends them, while introducing yet another colour and tone.

Step 3

To suggest a graded mixing of colours, I loaded two greens onto a small brush and pulled the brush down in regular short strokes on the surface. As you move the brush each time, the colours run into one another.

Step 4

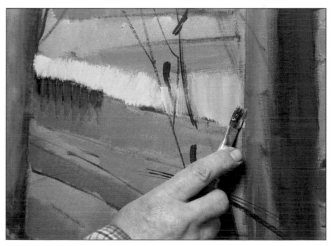

For the line above the dark green strokes, I loaded paint, gel medium and turpentine onto the side of the brush and used quick brushstrokes to blend everything together and thus produce a more even colour.

Using Oil Mediums

Step 1

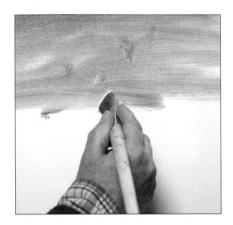

Step 2

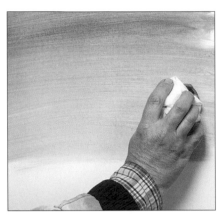

Step 3

To use gel medium, squeeze a little out onto the palette and then pick it up and mix it into the paint.

The gel has the effect of making the layer of paint more translucent and workable. To flatten and blend the paint, wipe across it with a piece of clean paper towel, changing the towel regularly. The wiping also lightens the tone.

You can continue wiping down the surface with clean paper towels. Here, the result is similar to creating a graduated watercolour wash by diluting the paint as you get towards the bottom of the painting.

Painting Oil Glazes

Step 1

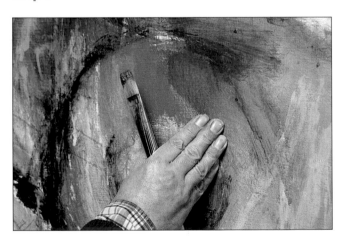

Step 2

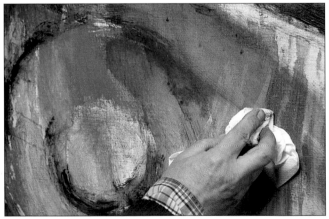

This technique works well on top of quite diluted layers of paint. Use gel medium and turpentine or white spirit to thin the paint, then apply it over the underlayer with the side of a brush. Push the paint into the canvas with your fingers or a clean, dry cloth.

So far, the new glaze has changed the colour, but not the shapes or forms, of the underlayers. To lighten the glaze, use the cloth to pull more of the glaze from the surface. Try to avoid using black or white to make up glazes, because they flatten the colours.

Blending Oil Paints

Step 1

The time you have available for blending depends on whether you use a medium – gel dries quickly, while turpentine evaporates. Here, I applied two different yellows quite thickly below the green crescent, without using any medium.

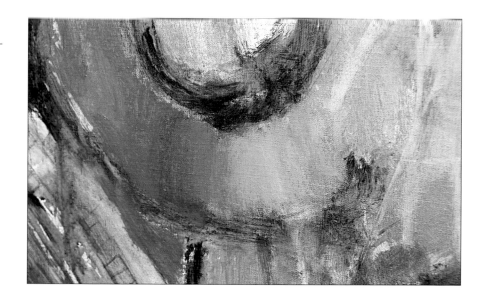

Step 2

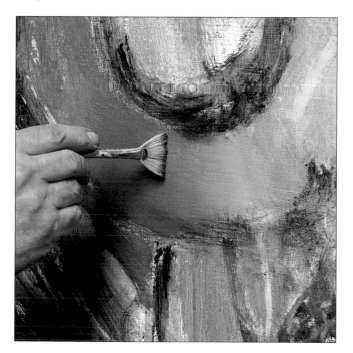

Drag a dry fan brush across the wet paint in a back-and-forth motion, gently pulling the colours together. Don't be tempted to use turpentine or white spirit to thin paint for blending; if the brush has any residue, dry it on a cloth or paper towel first.

Step 3

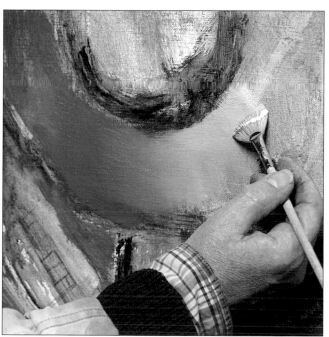

So long as the fan brush is completely dry, you can load all or part of it with more paint and apply it to the surface, blending as before. If you load the side of the brush, turn it over before blending, to give a smoother result.

Painting with Oil Bars

Step 1

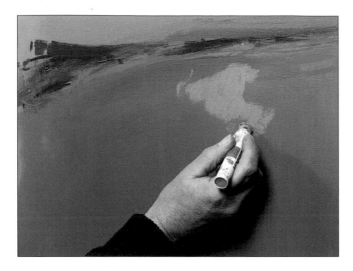

Most oil bars have a thin skin that must be removed before you use the bar. Although oil bars are clumsy for fine use, I find them good for overlaying areas, and for adding luminosity and texture over an acrylic wash. Push the bar into the ground quite firmly.

Step 2

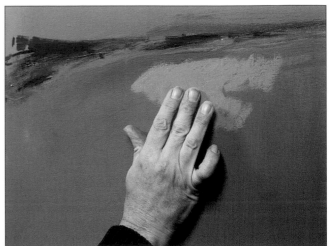

When you have a sufficiently thick layer of oil bar for your purposes, use your fingers – or a clean cloth or brush – to spread and blend it over the base wash. You can use oil-paint mediums in the same way as for oil paint.

Step 3

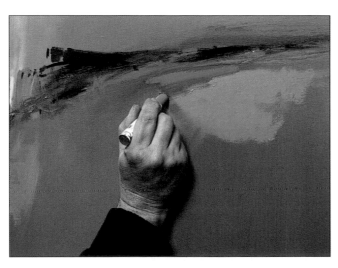

When you add a darker oil-bar colour firmly, it produces a more solid effect on the acrylic; and when this meets the blended bar, you end up with a blended, textural mix. You can spread this new colour, or leave it as it is.

Step 4

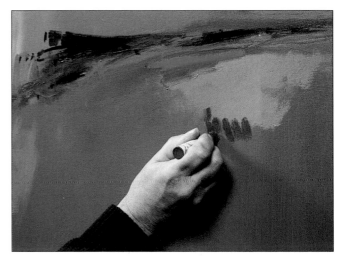

I often use an oil bar to make short, gestural marks that are similar to those that can be made with a brush, but more direct – because you can push the bar firmly onto the support, you can make rich impasto marks.

Painting with Oil Pastels

Step 1

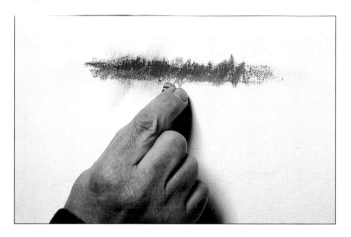

Step 2

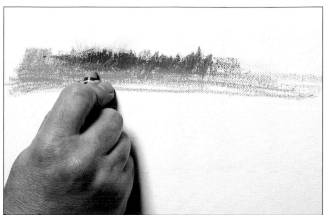

Oil pastels are harder than oil bars, and produce a drier, less juicy effect. In addition, they tend not to dry out. For an immediate textural effect, rub the oil pastel into the canvas hard: the more you work the stick, the deeper the effect.

As a contrast to the small, jagged marks of the last step, I applied the blue oil pastel using longer, freer strokes. As yet the colours are still separate, with quite defined edges at their borders.

Blending Oil Pastels

Step 1

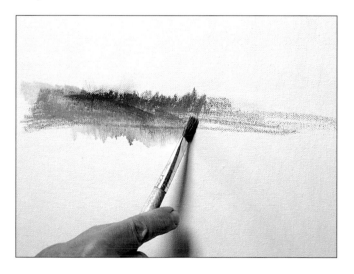

Step 2

Just as with oil paints and oil bars, use a thinning medium for blending oil pastels; I use an odour-free medium and a brush to create a glaze of a new blend of colours while leaving the original strokes still visible.

You can achieve interesting effects by applying a fairly diluted acrylic wash over the oil pastels: a top layer of pure acrylic; a layer where the acrylic covers the plain pastels; and where the acrylic is pushed away by the medium, you get a resist effect.

Brush Techniques

Step 1

Obviously, there are as many brush techniques as there are painters; here, I concentrate on ones for acrylic paints, as this is the medium that works most quickly for large canvases. Use a decorator's brush to put on an underlayer, forcing the bristles out to get a broad stroke with lighter edges.

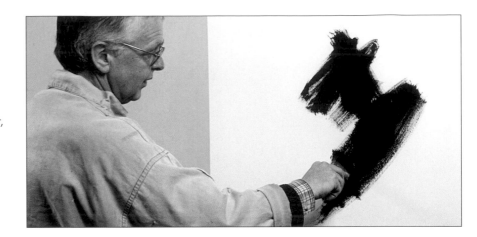

Step 2

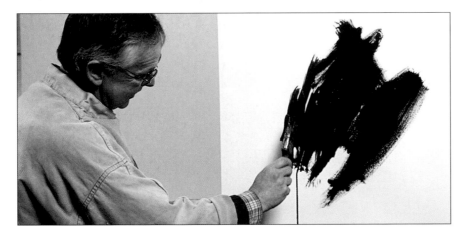

To create drips, fully load the brush with very diluted paint and apply the paint using the side of the brush. Where the drips run through a wet first layer, they take some of the first colour with them onto the blank areas of the surface.

Step 3

You can use a hair dryer to speed up the drying process between layers or colours; a fast and hot setting is best. Drag the next colour into the side of the first layer, using light, varied strokes across the surface to cover the underlayer in parts and let it show through in others.

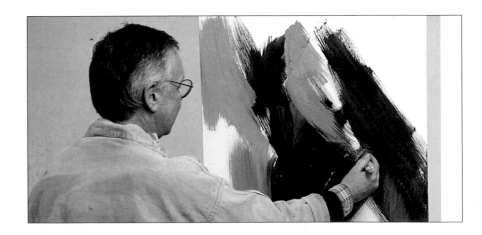

Spattering Paint

Step 1

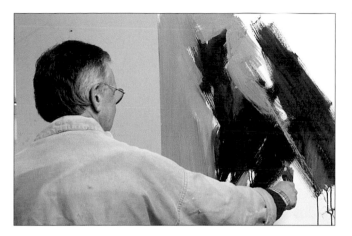

Step 2

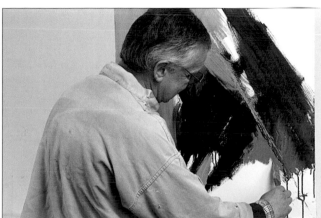

Stand back from the canvas – here, I am 45cm (18in) or so away – and flick a well loaded brush directionally onto the surface. The amount of dilution and loading can only be found by experiment: too thick and the paint stays on the brush, too thin and it goes everywhere but the support.

Using a new colour and a smaller brush (I used the decorator's brush for the spattering), make the next strokes. The line of the spattering dictates the form of the painting: you use what you have, and think about how this can be developed.

Step 3

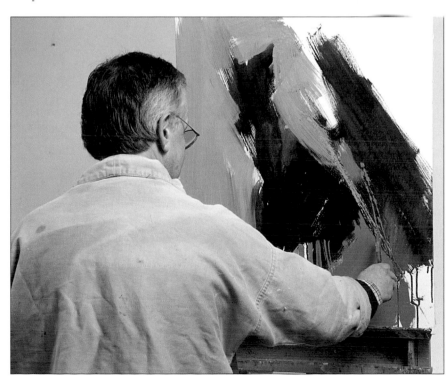

Using different parts of the brush for spattering brings different results. A small brush flicked side on makes thinner lines of paint, while paint from the broader face creates a less defined line which is less controlled and more separated, but which is still linear.

Creating Textures

Step 1

Using watercolours, take the time to prepare everything beforehand as always, and make up more washes than you are likely to need. Apply quite diluted washes, blending as you go, then dab watercolour ink onto the wet paint, using a brush or the ink nozzle. This creates pale edges.

Step 2

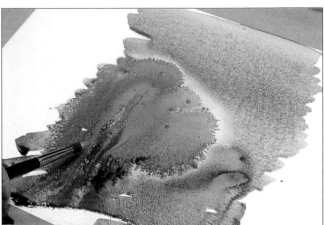

To create the groundwork for a varied series of effects, I spattered some gold ink with the side of a brush, and then blended it into the other coloured inks.

Step 3

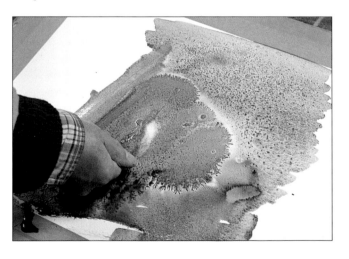

Let the inks and paint dry a little – until the gloss of the water has evaporated -- then scatter or pile table salt onto the layers and leave to dry completely. This is a really random technique that you can do nothing to control; put the salt on at different stages and observe the results.

Step 4

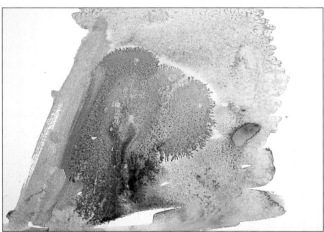

When the salt is bone dry, brush it off – I leave the areas that stick on – and think about how to use the texture. There are likely to be different results from area to area, depending on how wet the paint and ink were, and how much salt is applied.

Step 5

Draw over the painting with a pastel stick, blending the dust where you can. Because the pastel can't be blended over the salt, the texture in these areas ends up raised and uneven.

Step 6

I chose similar pastel colours to the watercolour and ink layers, and blended them with my finger to smooth and reinforce the gradations.

Step 7

You can also use pastels to make hard, free marks; don't be afraid to really push the stick into and over the surface and the salt — if the soft pastel crumbles on the salt, blow away the dust and continue making marks.

Step 8

The more layers you add, the greater the number of effects and textures that become possible. Working more colours into the marks already made means that the texture in this area becomes denser and more crumbling, with the remaining salt still breaking through the heavier layers.

Developing Paintings

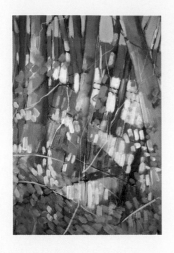

Each project in this section is designed to stand on its own merits, although you can mix and match both the techniques and the thinking. The degree to which each painting goes beyond realism is varied: moving into abstraction is a personal response, and the projects are intended to free your own creativity.

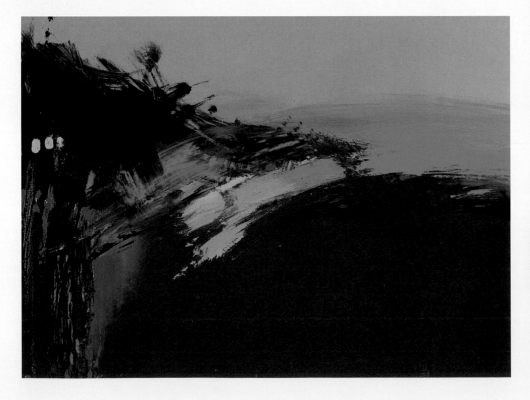

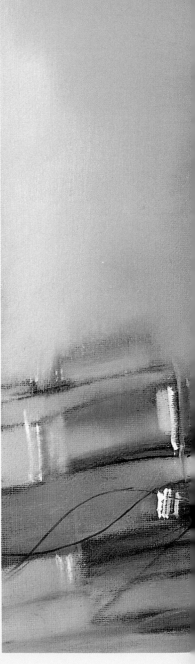

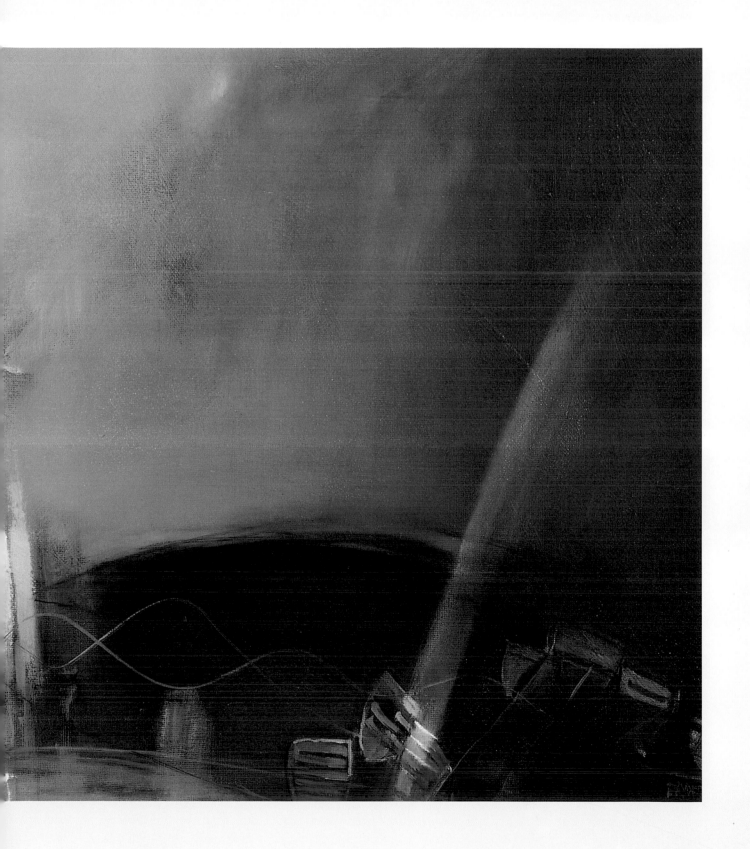

Urn and Peacock

Mixed media

This project is a continuation of a series of paintings that I produced quite recently, the idea being to take the viewer on a tour of an imaginary garden (*see below*). In this instance, the subject matter and composition were chosen specifically for the flow of design and complementary colour opportunities – of blues against oranges – which provide much of the impact.

This particular painting is not, to my knowledge, related to any other specific artist's work or style. The choice of mixed media – watercolours, ink and pastels – turned out to be ideal for the wildly varying textural qualities that I wanted to convey.

Preliminary sketches

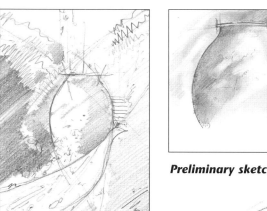

The paintings at right and below are part of a 'Garden' series of eight, which all share the same strong blues and greens as a central theme. I didn't set out to produce a series, but having completed Entrance to the Garden *to my satisfaction, I decided to take the viewer on a tour of an imaginary garden painting by painting.*

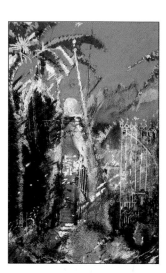

Entrance to the Garden

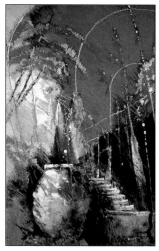

Urn and Steps **Chickens and Beanpoles**

Step 1

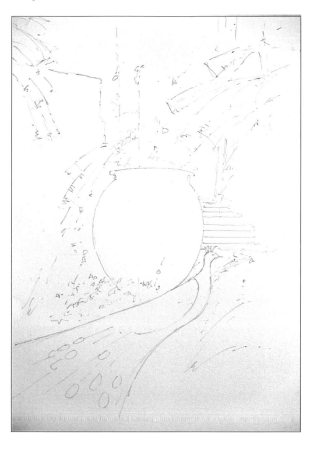

Step 2

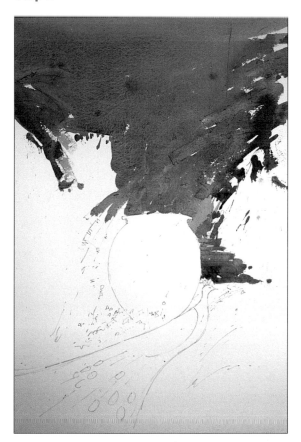

Drawing the composition

I began by stretching the watercolour paper – Saunders Waterford 410gsm (200lb) NOT surface, which was sufficiently robust to stand up to the amount of working it was going to receive in the building-up process – which is something I always do, regardless of the weight I am using. This may go against the prevailing wisdom, that you should stretch only the lighter weights of paper, but it is part of my preparatory build-up to doing a painting – almost of therapeutic value.

This process involves completely wetting the paper and taping the edges to a board and allowing it to dry, which gives a taut surface on which to work. Working from my preliminary sketches with a sharp 8B pencil, I lightly drew in my composition, giving careful consideration to the overall design I wanted, particularly in terms of where the strongest colours would go.

Applying the first washes

I began the painting process with a watercolour wash of ultramarine blue, followed immediately by suggesting foliage using the same blue mixed with cadmium yellow. After applying these colours with a No. 14 round sable brush, I allowed them to run into each other.

While the original drawing was quite detailed I was not concerned about the colours blending into each other at this stage, since my intention was to reinstate the details later in the process.

Step 3

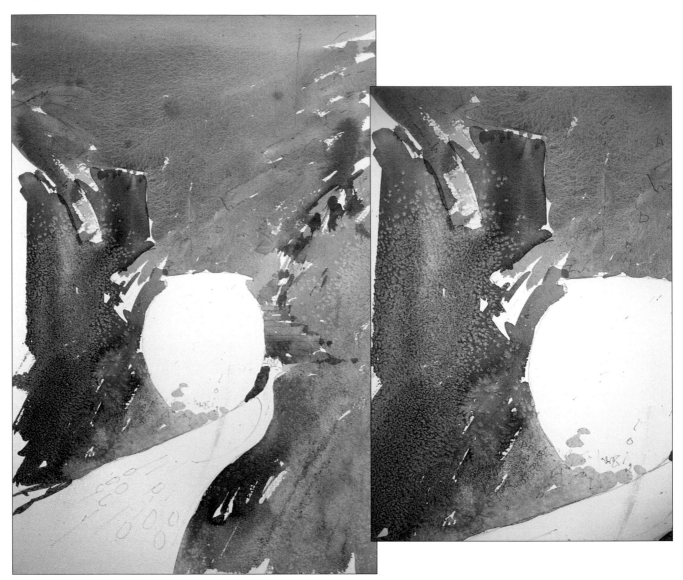

Creating a speckled effect

Using the same green as in Step 2, I added more washes to either side of the urn and peacock, this time darkening the mix with more pigment and the addition of alizarin crimson.

On the right-hand side I painted a thin wash of cadmium red with raw sienna, which I allowed to run into the green. As these two washes began to dry I spattered them with clean water, and then dropped in granules of ordinary table salt to create

texture. I applied the salt unevenly to give a varied result when it dried, and brushed any granules remaining off the surface, leaving a speckled effect where the salt had soaked away the paint (*see inset*).

See Adventurous Painting Techniques

| Creating Textures | **page 24** |

Step 4

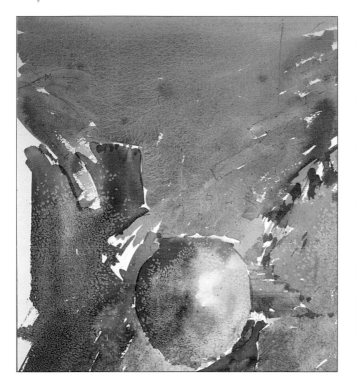

Step 5

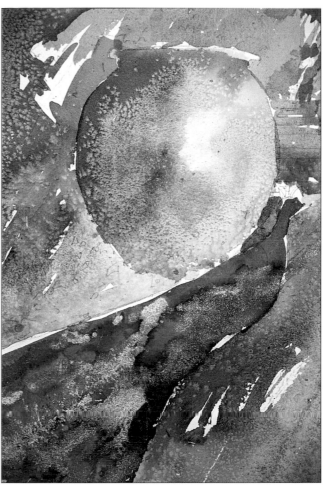

Adding the shadows

To bring all areas to a similar stage of development, I now painted
the urn. Using a No. 14 round sable brush, I began painting the
urn with a thin wash of light red mixed with cadmium yellow,
allowing ultramarine blue to bleed in, thus making a purple effect
to create the shadow side. To preserve a highlight, I removed some
of this colour with a dry cloth while it was still quite wet, and then
dropped on more salt and left it to dry.

Painting the peacock

Using the same sable brush, I painted the peacock with mixes of
ultramarine blue and cerulean blue, adding cobalt blue and
emerald green ink while the underwashes were still wet. As this
began to dry, I spattered in some gold ink using the same brush,
which gave an iridescent effect to the tail.

See Adventurous Painting Techniques

| Spattering Paint | **page 23** |

Step 6

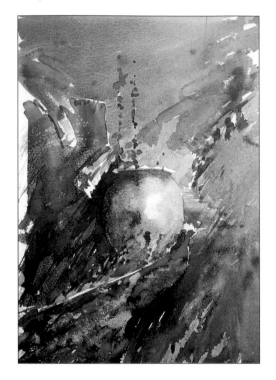

Defining the composition

To complete the watercolour base, I darkened the main green foliage areas on either side of the urn and peacock, applying thicker paint with the No. 14 sable brush. I repeated this darkening procedure to the red area on the right-hand side. In doing this, I increased the definition of my composition – my thinking being that it might also be useful to have the dark base areas of watercolour on which to paint light marks of pastel later on, for maximum contrast.

Step 7

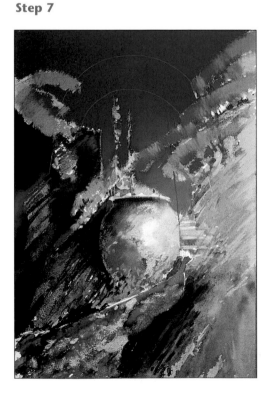

Strengthening the sky area

Having established my base to my satisfaction, I applied a strong deep blue pastel into the sky area, using a different lighter blue as I approached the urn. I then blended this entire area with my finger to give the colour the overall consistency I wanted. I decided to introduce the idea of a curved pergola to break the sky area just slightly, bearing in mind that if I decided to keep it, this would need further development at a later stage.

See Adventurous Painting Techniques

| Creating Textures | page 24 |

Step 8

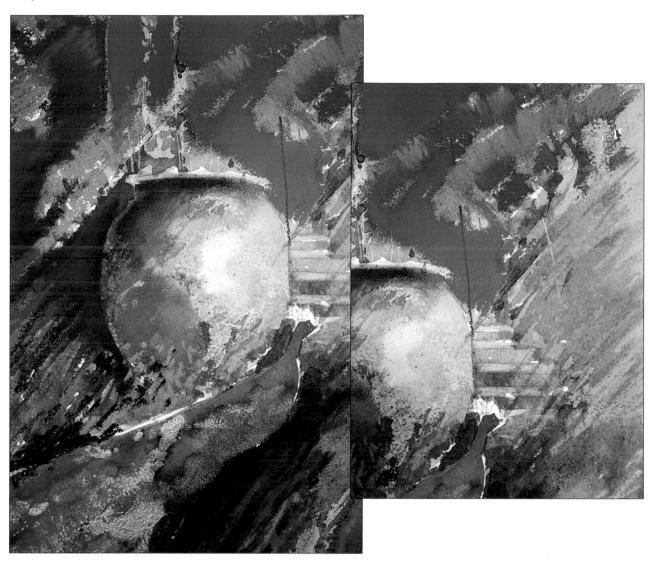

Building up the colours

The very colourful, busy bottom half of the painting is intended to act as a foil for the much quieter area of deep blue sky at the top. With this in mind, I used five different greens to suggest increased depth to the foliage. To start, I created the very dark areas just below the peacock with a deep dark purple pastel.

Then, with a combination of yellows and pinks, I put pastel on the right-hand side to echo the colours I had used to create the urn. For the further modelling required to achieve the desired shape of the urn, I applied various reds, moving to a quite strong purple for the shadow side.

I painted some of my very deep blue into the peacock tail to mirror the sky. To give the sky more impact, I then suggested some brightly coloured flowers in the urn itself. At this point I sprayed the entire painting with fixative, so that I would not lose what I had done so far – although, of course, I had the option of working over it later.

Step 9

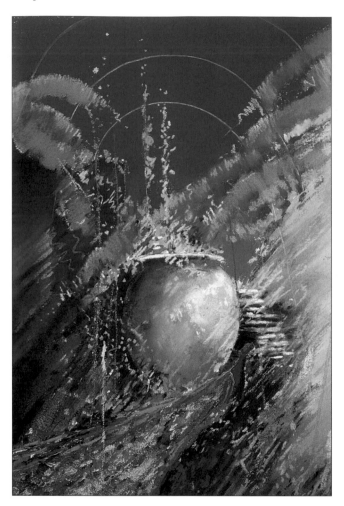

Detail

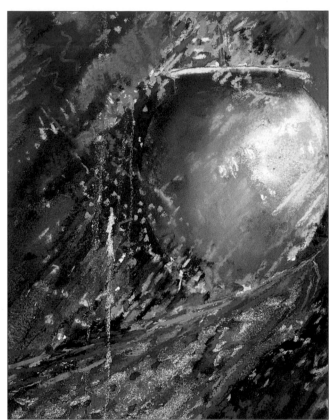

Bringing in details

Using red, orange and yellow pastels, I indicated more flower heads. Having made the decision to keep the pergola in the composition, I gave it greater emphasis with a light-coloured pastel pencil.

With the same pencil I drew some fine lines into the peacock to indicate the presence and direction of tail feathers. I then carried out further modelling on the urn and the adjacent steps, and strengthened the pinks and oranges on the right-hand side of the painting.

Blending the pastels

Using a clean, dry No. 6 watercolour brush, I gently dusted the entire painting to remove any loose surface pastel; this also very slightly blends one colour into another, giving an added softness in appearance.

I dabbed some more gold ink onto the peacock tail, followed by some dabs of dark and light blue pastel. Using the little gold ink that remained on the brush, I spattered in an upward motion through the painting – you can most obviously see the results of this in the sky area. I then sprayed the entire painting with fixative as in Step 8.

See Adventurous Painting Techniques

Spattering Paint	page 23
Creating Textures	page 24

Step 10

Knowing when to stop

In this final stage I wanted to pull the painting together with some minor additions of pastel colour and a highlight here and there. To do so, I lightened the top edges of the green foliage and added more light green marks at the base of the urn. I then added some highlights to the steps and additional light blue marks to the peacock's tail. The bottom right-hand corner of the painting needed some added interest to draw in the eye, so I indicated some orange flower heads in the foreground.

The arch-enemy of all artists is not knowing when to stop, and this type of painting is, for me, the worst of all in this respect. I began to apply small squiggles of green in various places to add interest, and felt myself being drawn into the trap – so I stopped painting!

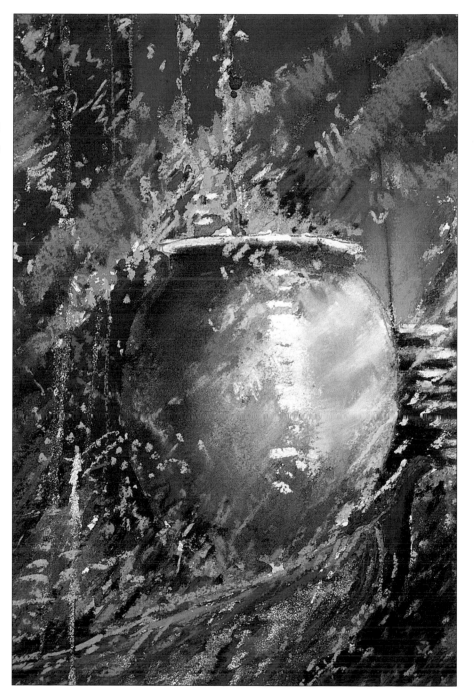

Urn and Peacock
33 x 45cm (13 x 19in)
Mixed media on 410gsm (200lb) NOT watercolour paper

It would be very easy to have overstated the peacock's tail, but I didn't want to do this. The painting is designed to flow easily throughout, and each separate element is treated equally as part of the whole.

From the beginning, I designed a flow to the composition. The blue of the sky flows down through the centre of the painting into the peacock, the strong directional flow of the greens gives a link across the sky area, and the pinks and yellows are taken across the distant white steps onto the urn itself.

Water Lilies

Watercolour and soft pastel

Probably the most famous exponent of water lilies as a subject for painting is Claude Monet, and it would be almost impossible not to have his works in mind at the outset of a project such as this; however, to avoid too strong an influence I chose to use watercolour and soft pastels as opposed to oil paint, Monet's most commonly chosen medium.

The two photographs shown here were used only as reference material of a scene, and the painting is an amalgam of both of them, with the water lilies added as a central theme. Again, this was a very conscious decision, as I wanted the painting to include water lilies as a part of the composition, rather than allow them to fill the canvas to the exclusion of everything else.

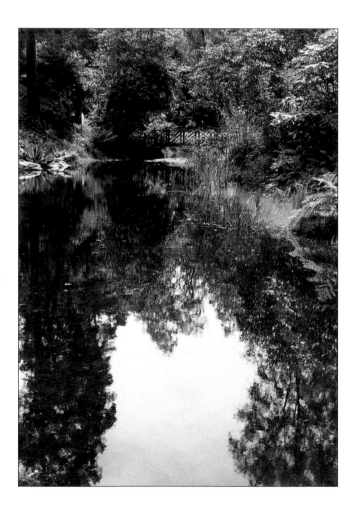

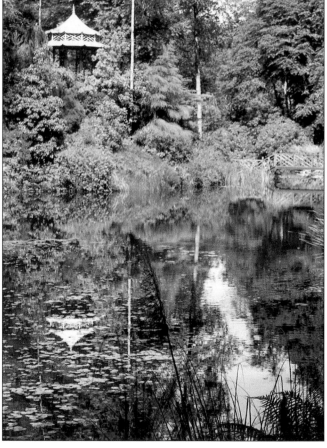

A way of starting

I find photographs very useful as reference material with which to get a painting started – and both the prints shown here were ideally suited for this purpose. Once I decided how the painting was to develop, I stopped looking at the photographs altogether.

Hard and soft

I was initially attracted by the hard lines of the bridge and pergola, in stark contrast to the much softer surroundings of the garden greenery. This type of subject provides wonderful opportunities for 'lost and found' lines that, in turn, create interest.

Step 1

Step 2

Establishing the composition

Working from my reference photographs, I began by drawing my composition using a sharp 6B pencil and small amount of pastel pencil, which I used as an outline for the bridge and pergola. The pastel pencil gave a more distinct edge and a feeling of solidity to these two objects, creating a contrast to the softness of line that is found elsewhere.

Applying the first washes

I wanted to give the finished painting a soft feeling, and chose cerulean blue for the sky area and as my base blue for mixing the greens. I therefore painted a wash of the blue into the sky with a No. 14 round sable brush. Immediately afterwards, using the same brush, I painted in various mixtures and strengths of green using the cerulean blue mixed with cadmium yellow; in some parts, I floated a little raw sienna into the mixture.

While this was still wet, I introduced some burnt sienna in the middle right and added some of the same colour to the green mix, in order to achieve a darker green on the middle right, above and below the bridge and into the pergola, thus providing a strong contrast.

Step 3

Step 4

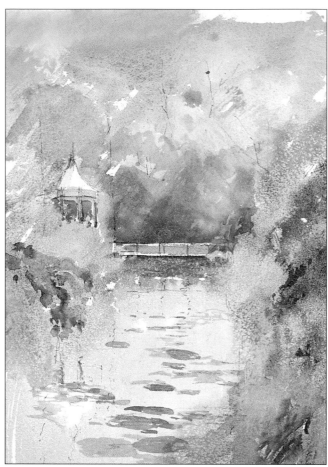

Creating textures

While everything was still wet, I painted in the water using a wash of cobalt blue. As soon as I had completed this I gently wiped the entire water area in a downward direction with a dry cloth, removing the colour completely to indicate where the pergola roof was to be reflected. I then flicked some green paint, quite randomly; the interesting hard-edged effect this creates is something that I might decide to capitalize on later.

To give this base a texture, I applied ordinary table salt quite liberally to the main areas of greenery on the left and right. To achieve two quite distinct results, I first applied the salt when the paint was very wet, and then sprinkled salt again when the paint was partially dry. Doing this allowed me to brush away only some of the salt by gently rubbing with the fingers, whereas the initial application remained firmly stuck to the surface of the painting.

See Adventurous Painting Techniques

| Spattering Paint | page 23 |
| Creating Textures | page 24 |

Changing the effect

I darkened the greens above and below the bridge, using a fairly thick mix of ultramarine blue and cadmium yellow applied with a No. 14 sable brush.

At this stage I became conscious that the pergola and bridge were competing as the main centre of interest due to their rigid linear construction against a soft background; this was further exaggerated by the use of red alongside the dark green.

I decided to subdue this effect by darkening and adding more detail to the foreground water lilies while painting into the pergola and bridge, thus breaking the harsh, straight outlines apparent at present. In order to do this, I put away my watercolours and progressed from here using only pastels.

Step 5

Developing the sky and foliage

I began by working over the sky area with three different light blue pastel colours, blending them together, where necessary, with my finger. I made some isolated marks in the greenery with these same blues to indicate gaps in the foliage.

Using four or five different soft green pastels, I added further marks and detail to the foliage, working from the top downwards; I blended some of the marks and left others as they stood, to add interest to the overall effect.

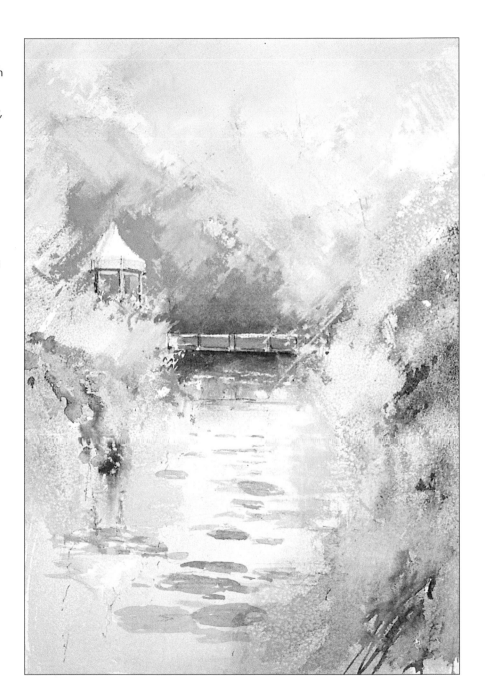

See Adventurous Painting Techniques

| Creating Textures | page 24 |

Step 6

Increasing the colour range

I began to add some lighter blues into the water area and then blended in some soft greens to suggest reflections. Next, I applied some orange pastel to the middle right burnt sienna area to increase the contrasting effect against my greens. I then started to define the water lilies with green pastel, adding pink marks to suggest flowers in certain areas.

To re-establish a sense of order I drew back into the bridge and pergola, and also suggested some branches in the foliage on the left and right (*see inset*).

Step 7

Introducing highlights

Before swinging the central point of interest into the foreground, I sprayed the painting with fixative to avoid disturbing the colours already applied.

I wanted to achieve a 'now you see it, now you don't' effect with the red on both bridge and pergola, so I applied the light greens over these areas and then introduced highlights of red pastel. I continued the composition with marks of light green soft pastel, working towards the foreground.

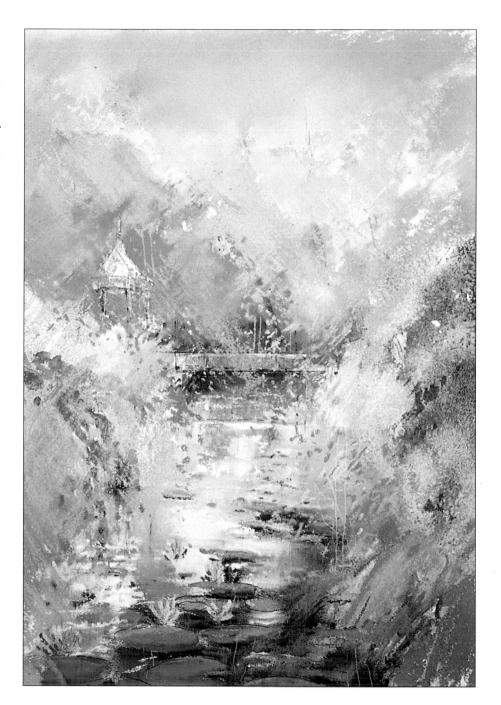

Step 8

Step 9

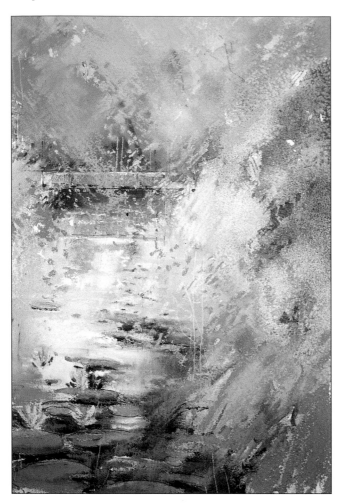

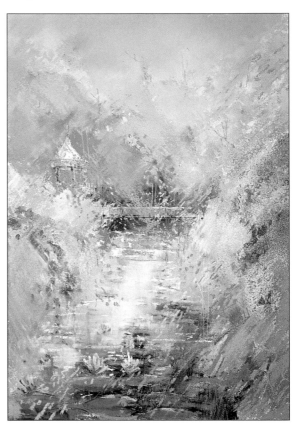

Creating softness and definition

To create a softness in the water I used off-white, pale yellow, some light blues and a purple soft pastel, working the colours until I achieved the effect I wanted.

I increased the definition of the water lilies by applying a darker green surround. I then reinstated the pinks on the flower heads and added a few more marks of orange and green to augment the cascading effect on both sides of the painting.

Pulling the composition together

This stage was concerned with pulling the whole painting together to give a semblance of overall unity, echoing the background colours in the foreground and adding final marks and dabs of colour where necessary.

I added quite a lot of colour into the water to reflect the busy areas on either side, blending all the while to give a softer feeling to the result. I made the blending of colour more exaggerated in the central area, so that it would lead the eye towards the water lilies in the foreground. I defined the shapes of the water lilies themselves by adding more greens, taking care to make any marks in an elliptical shape to enhance the effect.

Step 10

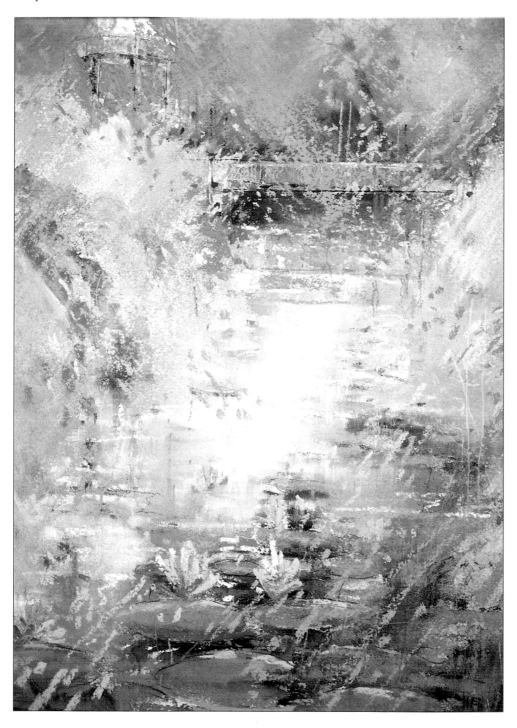

Adding the final touches

I completed the flowers with more pinks, light yellow and orange. At this point the lilies looked a bit stark in contrast to everything else, so I decided to break up this area with some diagonal strokes of green and orange, which strengthen the overall feeling of damp, tumbling undergrowth near the water's edge.

Using a light blue I worked back into the trees, thus allowing more sky to show through; and finally, using a darker blue, burnt sienna and off-white pastel pencil, I drew in suggestions of twigs and small branches in a random fashion to act as a foil to the larger areas of colour.

Water Lilies

43 x 33cm (17 x 13in)
Watercolour and soft pastel on 300gsm (140lb) Arches paper

The close harmony of colour and tone gives this painting a softness in appearance with little feeling of depth or perspective, except in the central area, where I have suggested the water flowing into the middle distance.

I avoided the perhaps obvious choice of placing the water lilies in a central position and put them right in the foreground, allowing them to spread out of the picture with the intention that the eye should encounter them before moving along the water to the pergola and bridge.

By using this type of compositional approach, and by choosing watercolour and pastel as opposed to oils, I feel that I was able to achieve the result I was after from the start, without getting caught in Monet's slipstream.

Step 1

Step 2

Establishing a base colour

To begin with, I completely covered the white of the canvas with orange and pink oil-based pastels. I spread the pastels evenly by rubbing them with a piece of paper towel whilst applying some turpentine with a brush to 'loosen' the oil pastel; this helps the blending process and allows the texture of the canvas to come through the paint (see inset).

I then left the base colour to dry for a short time, allowing some of the turpentine to evaporate, before going on to the next stage.

At this stage, I was thinking about compositional elements. I wanted to include an area of sky – in reality this landscape is often separated from the sky by a distant hedgerow or line of trees on the horizon, and this was an idea I wished to incorporate in the finished painting.

Sorting out basic texture

From this point on, I was looking to form a comfortable balance of line, form, texture and colour which would influence how the painting developed; I now used quite thin acrylic colours mixed on and off canvas in broad areas.

I applied a further area of pink oil pastel to the top part of the canvas before adding very diluted washes of acrylic with a No. 12 bristle brush. As this was drying, in order to add interest and texture before applying the next layers of thicker paint, I rubbed the paint with a cloth, removing the surface in some places whilst allowing stains of acrylic to remain in others – it is a good idea to rub the paint at intervals while it dries, as this produces a varied and more interesting result.

See Adventurous Painting Techniques

| Painting with Oil Pastels | page 21 |
| Blending Oil Pastels | page 21 |

See Adventurous Painting Techniques

Painting with Oil Pastels	page 21
Painting Acrylic Washes	page 14
Removing Acrylic Paint	page 15

Step 3

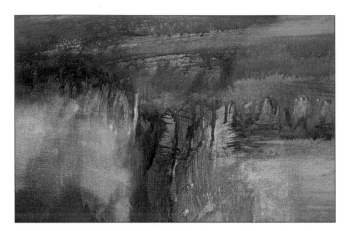

Step 4

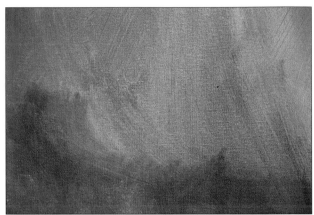

Combining washes and pastels

The steps on this page explore areas of Step 2; by now the painting seemed almost to develop itself, as I was carried along with the process and became aware of ways in which I could harness chance developments to maximum effect. Some of the marks left by rubbing back allowed some parts to dry longer than others, which provided me with a 'no-risk' opportunity to create texture in interesting patterns that I could use in the final stages of the painting. If I decided not to use them, I could subsequently paint over them.

This particular area, at the top left, could, in fact, stand up well as a finished piece of work in its own right. The detail clearly shows the thin washes that suggest the trees on the horizon, which allowed the paint to run, and the glow of the pastel, which I decided to retain in places as reminiscent of the far fields.

Making loose brushstrokes

I applied the oil pastels very thinly in some places and slightly more thickly in others, so that the acrylic could 'take' to the thin layer and not to the thick, giving me a more interesting effect. Too thick an application of oil pastels results in them rejecting the acrylic layer.

This area of the painting, at the bottom left, clearly shows the thin layer of acrylic paint. The overlays and thin glazes of colour are reminiscent of the way Turner would sometimes work to give a layered effect and, if desired, a glow to the painting, produced by the thinness of the paint layers.

The other element demonstrated is the looseness of brushwork, which was very important as a base at this stage, as it provided a textural quality against the larger blended areas; it is always more interesting to use contrast – this may be light against dark or, as in this case, a textured area of busy-ness against a blended area of relative calm.

See Adventurous Painting Techniques

| Painting Acrylic Washes | **page 14** |

See Adventurous Painting Techniques

| Brush Techniques | **page 22** |

Step 5

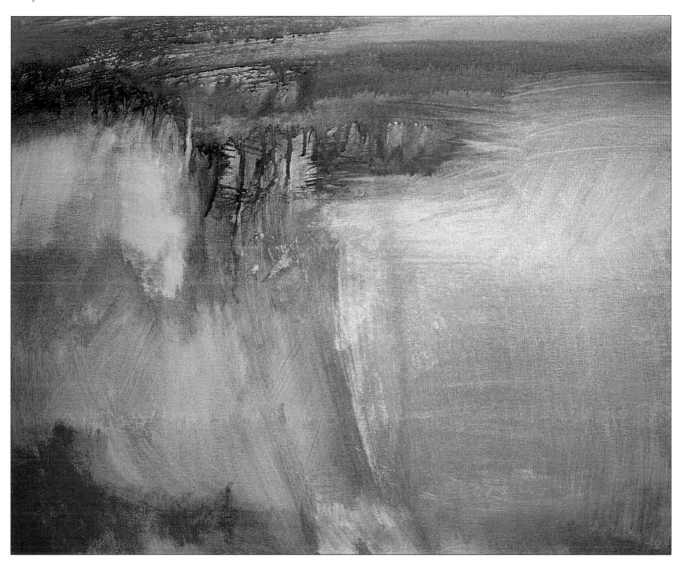

Adding white

Now I could introduce some white into the painting, adding it to the colours where previously I had allowed only the white of the canvas to show through – this included all the red except the bottom left-hand corner, and the tree line and horizon that run along the top.

It was important to keep the white quite thin at this stage, to avoid progressing the painting too quickly; it is still very much a tentative, thinking process at this point. However, I added some detail to the meeting of the red and green, to bring a modicum of order to the chaos – the development process always alternates between these two stages, and the key to achieving what you want is to finish on the right one.

Step 6

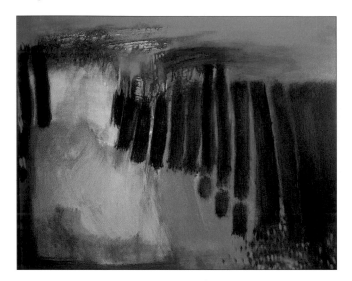

Painting the lavender

Using very thin, dark paint, I next applied the strips of lavender, keeping them relatively evenly spaced. The exceptions were those on the right-hand side which I blocked in to a greater extent to suggest where the green of the field did not show through the lavender, and a strip on the left-hand side, which I included to suggest a continuity of fields outside the painting itself – unlike in the photograph, where the lavender takes up the full width.

I took great care to avoid painting over the top left-hand corner to ensure that this area maintained its texture from earlier stages.

Step 7

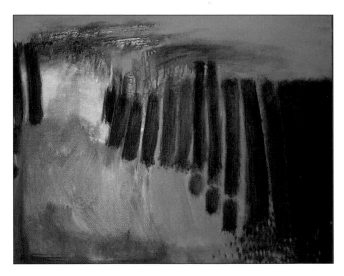

Working around the lavender

It was now time to start pulling everything together; I did this by painting over the greens, oranges and sky blues into the texture at top left and forming strokes to paint into the lavender. I added white to the purple lavender strips in order to confirm their exact positions, and to suggest the paleness of the area beyond the lavender in the actual view.

Note the area which was intended to suggest other flowers and general interest at the bottom of the canvas. Here I took care to use areas of flat colour that worked immediately alongside the textured marks to create interest and an effect of vibrancy.

See Adventurous Painting Techniques

Brush Techniques | **page 22**

Step 8

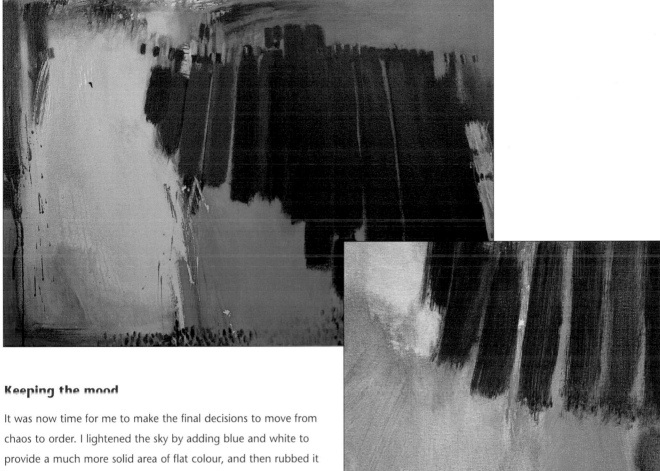

Keeping the mood

It was now time for me to make the final decisions to move from chaos to order. I lightened the sky by adding blue and white to provide a much more solid area of flat colour, and then rubbed it out where it met the texture at top left.

A detail from the middle of the painting gives an indication of how I kept the painting quite thin and loose, even while I was building up the colour in readiness for the final stage (*see inset*).

I applied more orange and green, with whites to strengthen the colours already on the canvas, and added various, quite random, marks along the bottom edge to achieve the effect of single groups of flowers.

Where I mixed white with purple to redefine the lavender strips, I did this not by simply leaving gaps between each strip, but by adjusting the purple colour – rows of lavender do overlap when in full bloom, and it would have been a mistake to ignore this.

The most important thing at this late stage was to avoid overworking the painting while continuing to think about the overall effect – if the colours and shapes were satisfactory, unless there appeared to be anything that obviously required change, this was the time to put the brushes down.

See Adventurous Painting Techniques

Painting Acrylic Washes	page 14
Removing Acrylic Paint	page 15

Lavender Fields
Mixed media on cotton canvas
76 x 61cm (30 x 24in)

Standing back from the canvas, I felt that the overall shape had come together. I did not want to extend the lavender any further, and the areas of green and orange now seemed to be working together. It was time to declare the work complete.

While the painting is still well within the realms of representative art – few people approaching it would have trouble seeing the rows of lavender – I feel that the loose treatment and interesting textures capture a vivid feeling of the warm atmosphere and energy of the original scene.

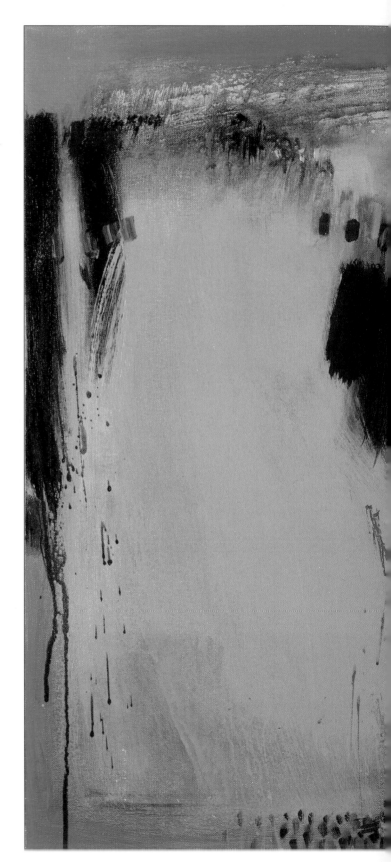

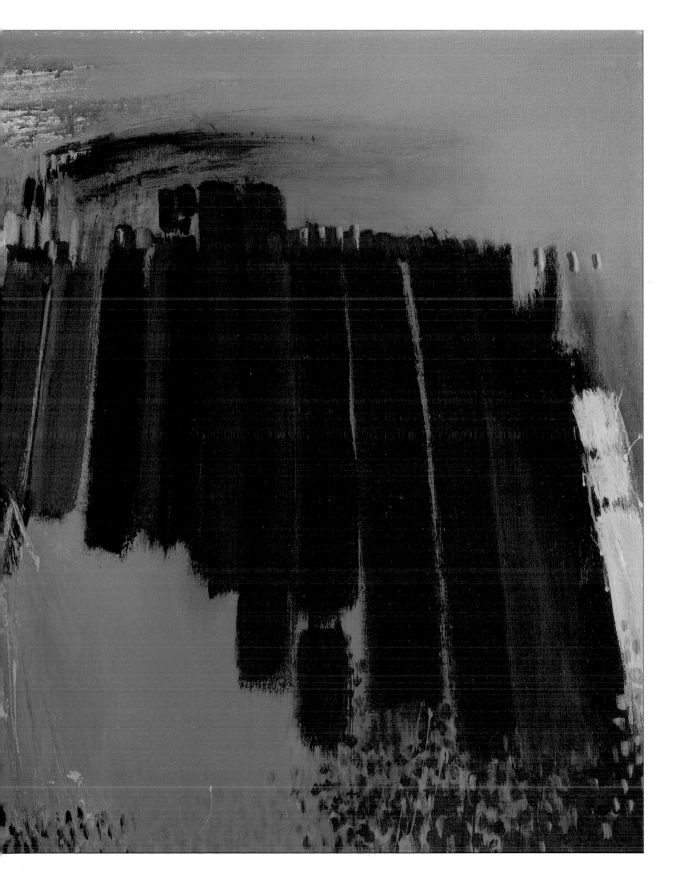

Poppy Field

Mixed media

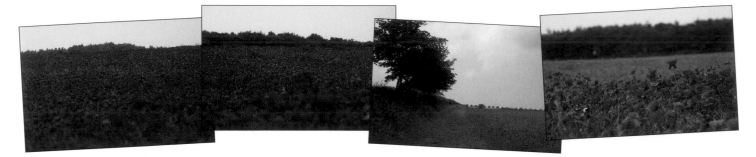

Something I have come to rely on as a source of inspiration is the annual appearance of poppies. I love the colours nature provides and, for my money, the intense reds, greens and, fortunately on this particular day, blues are very hard to beat.

Painting, certainly for me, is an emotional response to something, and an open field of poppies against a blue sky invariably reminds me of the debt owed to a previous generation for the peace and tranquillity it is our privilege and good fortune to enjoy today.

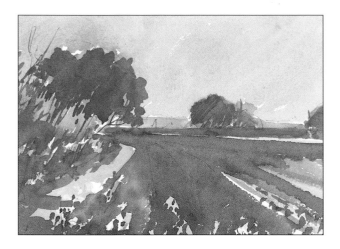

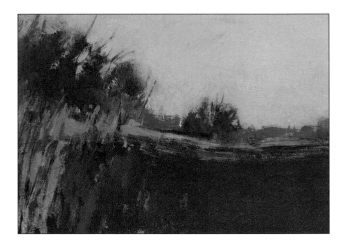

Combining images

The final painting is an amalgam of the four images shown above. On this occasion I didn't produce an on-site sketch, as my objective was to blend the four images into one piece of work, without favouring any one scene or view over the others. In the studio I then produced watercolour studies from the photographic reference material, in order to help me distil in my mind's eye the statement I wanted to make with the final painting.

The intensity of the oranges and reds against the blue was quite overpowering, and the idea of trying to reproduce beauty at this maximum output end of the spectrum seemed overly optimistic to me.

Finding the colours

With the watercolour sketches completed, I produced an oil sketch as a further preparatory stage in my planning – this was not my original intention, but as the process develops, things can change. My decision to make the oil sketch was based on the benefit I would gain from blending colours, which was the direction I wanted the final painting to take.

I decided on the overall design, which would result in me keeping the busy area of foliage on the left-hand side while linking the composition across the painting with the area of hedgerow. This also helped to keep, or hold in, the foreground poppy area.

Step 1

Step 2

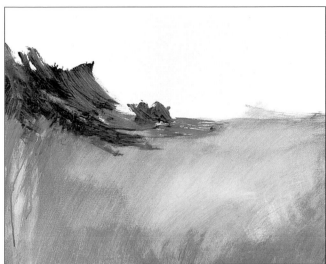

Priming and beginning

To give a toned background I primed the surface with a very weak mix of raw sienna, I decided to begin this painting in acrylic, knowing that, as the process gathered momentum, I would almost certainly introduce other media along the way. I started by freely applying Hooker's green and Prussian blue in thick and thin areas with a 2.5cm (1in) decorator's brush to establish the area of dark trees on the left-hand side. The application of acrylic paint mixed with varying amounts of water avoids total uniformity and thus creates a more interesting effect.

When this had dried, I laid the canvas flat and, with a dry cloth, gently rubbed and disturbed the surface to blend some of the water runs at the base.

Applying the base colour

To cover the rest of the canvas below the horizon line, as a base for the field beneath the poppy heads, I loosely applied a thin wash of emerald green into which I added some viridian. After this had dried for about ten minutes, I used a wet kitchen cloth to remove some of the paint and leave a much thinner surface on which to work.

At this point in development it occurred to me that the use of the complementaries green and red risked cancelling each other out – I would need to choose the reds very carefully. The risk, however, was diminished, as much of the green base would be painted over. I removed a little more of the base green wash, to leave very thin areas, while leaving some thicker passages, complete with paint runs, to give me some texture to use later on.

See Adventurous Painting Techniques

| Painting Acrylic Washes | page 14 |
| Blending Acrylic Paint | page 15 |

See Adventurous Painting Techniques

| Removing Acrylic Paint | page 14 |

Step 3

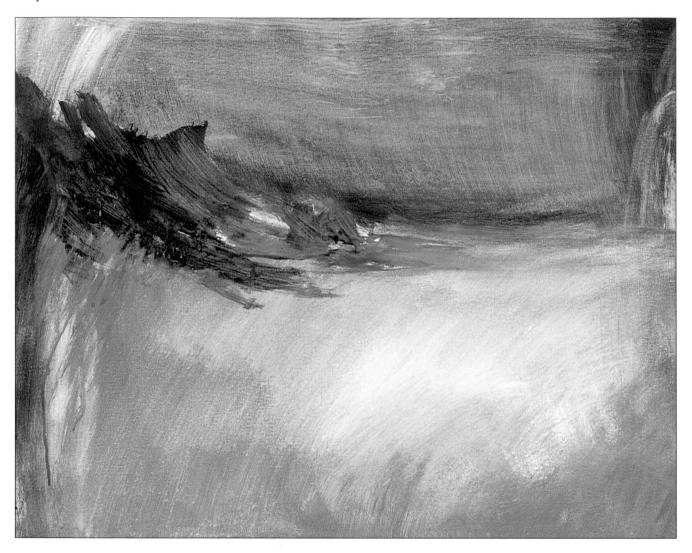

Starting the sky

I now turned my attention to the top half of the canvas. To lay in a thin wash of my sky colour, I used ultramarine blue and cerulean blue, and to gain the effect of some light coming through (without wishing to use white at this early stage) I introduced a light blue violet colour, rubbing back with a damp cloth where the opaque violets covered the initial tree area and were in danger of obscuring the initial brushwork.

At this point I had a fairly recognizable traditional landscape design – in this way I was able to retain the feeling I wanted

before proceeding to build up the painting in a more abstract way. The dark tree and hedgerow forms, taken from the initial photographs, were central to the overall outcome of the finished painting as a method of holding the composition together.

See Adventurous Painting Techniques

| Removing Acrylic Paint | **page 14** |

Step 4

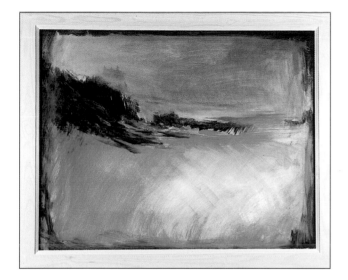

Step 5

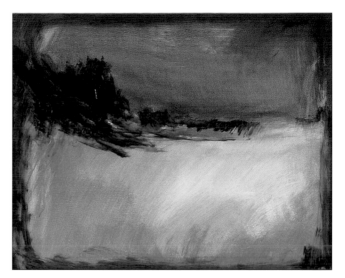

Taking stock

Before moving on any further, I put the canvas temporarily into a limewaxed frame; doing this helps me to see the flow of the painting and the areas of colour that I need to establish before taking more steps.

On standing back and viewing the painting in this manner, I realized that I wanted to re-establish the darks so as to reinstate the composition – this is all part of the continuous assessment process as the painting develops. I did this quickly and almost haphazardly with Hooker's green, applied the deep violet colour more liberally, and left the paint to dry in its thin and thick areas.

Developing the sky

I now decided to lay in more of the sky area and introduced a mix of white with some cerulean blue, keeping it quite thick in the top left. As I moved across the painting I added a little violet and thinned the mix down; and I swept the broader brushmarks into the dark green on the left and down the right-hand side using cerulean blue.

I kept the use of white to a minimum at this point, to avoid possible problems with chalkiness – white tends to make things lighter, not brighter, and too much white added early on in the process can give a muddy or chalky appearance due to its density. This can cause problems as you add more paint when building up the painting.

See Adventurous Painting Techniques

| Painting Acrylic Washes | **page 14** |

Step 6

Oil-bar colours and texture

I now decided to use a red oil bar to add some quite haphazard, vertical strokes in the foreground at the bottom of the painting to depict the poppy heads, followed by some dark green. I then introduced some Hooker's green in and around the red oil-bar marks; this also provided texture that would be painted over and scraped back when I came to apply the final acrylic colours.

Again, I took the opportunity to stop and review how the painting was developing overall. I continually stand back and assess the next move, and at this stage some fairly important decisions required consideration – for example, were there sufficient underlying colours? I decided to lay in some more blues and purples, knowing that these would shine through subsequent layers.

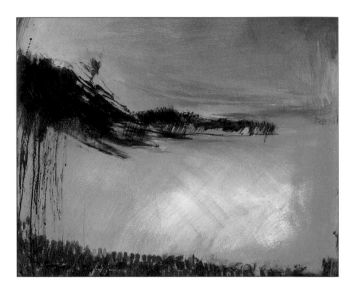

See Adventurous Painting Techniques

| Painting with Oil Bars | page 20 |
| Creating Acrylic Textures | page 16 |

Step 7

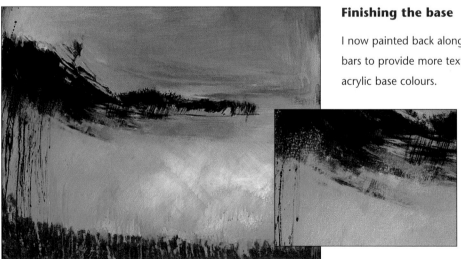

Finishing the base

I now painted back along the skyline, using green and purple oil bars to provide more texture before I came to apply the last acrylic base colours.

I like to achieve large areas of graded colour alongside detail and marks, as this makes for a more interesting effect, so I began by flicking and spattering dark green acrylic on the right- and left-hand sides, using the decorator's brush.

Before moving on, I added a few more emerald green acrylic washes, allowing them to run down through the reds. I then put on some more purple and blue in the mid-section and dragged cadmium red and emerald green oil bars across this area to give me more texture (*see inset*).

See Adventurous Painting Techniques

| Spattering Paint | page 23 |

Step 8

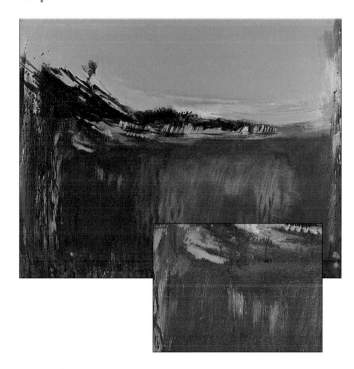

Starting the poppies

With the base established to my satisfaction, it was now time to apply the main poppy colour and pull the tentative marks together to blend out and create the effect I wanted to achieve in the finished painting.

I used a mixture of mainly cadmium red with various amounts of orange for the poppy colours to achieve a pleasing gradation and depth of colour – this was important to avoid a large area of the same colour, which would look very uninteresting in the finished painting. I applied this very loosely in thick and thin areas before I finally pulled it all together (*see inset*).

For the sky area I applied a mixture of light blue and some violet with the decorator's brush, making sure some of the background colours were allowed to show through.

Step 9

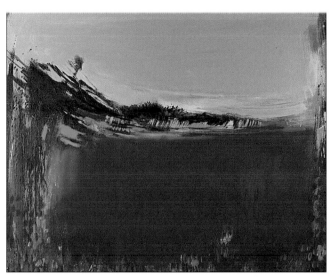

Reinforcing the reds

I added splatters of blue and red to the left and right-hand sides of the painting, and painted over very large areas of the initial greens, but allowed these to glint through in places, helping with the overall effect.

While the large areas of red were drying, I used a dry cloth just to blend them out and produce a slightly flatter and more even colour. In addition, I enhanced the texture by dabbing at the red area in the foreground with a large decorator's brush before proceeding to the next stage.

See Adventurous Painting Techniques

Spattering Paint	page 23
Blending Acrylic Paint	page 15
Brush Techniques	page 22

Step 10

Step 11

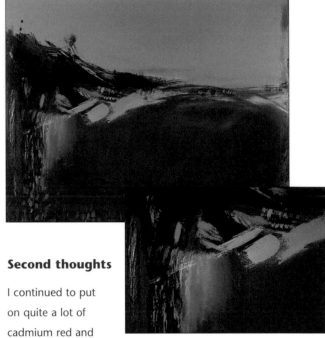

Reinforcing the colours

I allowed everything to dry before I started, very carefully, to apply red oil bar on the right-hand side at the base of the painting, beginning with marks which I then blended.

My concern now was to apply marks, shapes, lines, form and colour in such a way as to achieve a pleasing overall design, but without falling into the trap of pushing and prodding the paint around too much.

There appears to be an almost universal belief that the longer we paint the better the outcome – but from results we all know the reverse to be true. No painting, whether representational or abstract, will tolerate such excess, so this was a particularly perilous time, which required self-restraint if I was to avoid an overworked, incoherent muddle!

Second thoughts

I continued to put on quite a lot of cadmium red and orange oil bar in fairly broad areas, as well as marks across the poppy area, and then decided to leave the painting to dry overnight in order to reassess the overall structure the following day. Time spent away from a painting allows the making of objective decisions about where to go next much easier when you return to it.

The next day I was not so sure whether the heavier darks I had added following the reds of the poppies were taking the painting in the direction I wanted, so I altered the sky area to a lighter blue and then painted into, and across, the darks to soften the area before splattering on some more darks on the left (*see inset*). I linked the darks across the painting and again waited until it was completely dry before commencing the final phase.

See Adventurous Painting Techniques

Painting with Oil Bars	**page 20**
Creating Acrylic Textures	**page 16**
Spattering Paint	**page 23**

See Adventurous Painting Techniques

| Painting with Oil Bars | **page 20** |

Step 12

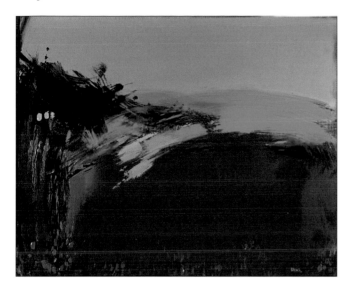

Reworking the composition

Having reached the final stage, I realized that I had kept attempting to drag the blues into the reds and vice versa – an unsatisfactory blend. I was also becoming uneasy about the halfway split between the blue and red as the main broad areas of colour division because, by definition, it split the composition in two. In a design sense, this equal split is very uninteresting and pulls the eye of the viewer out of, instead of into the painting. I decided something needed to be done, and that whatever it was would need to be a bold step to achieve the necessary improvement in the existing composition.

I decided to use two greens – emerald green and viridian – brushed together across the central area in the opposite direction to the marks previously applied – again, this was done to add interest and movement.

See Adventurous Painting Techniques

| Blending Acrylic Paint | page 15 |

Step 13

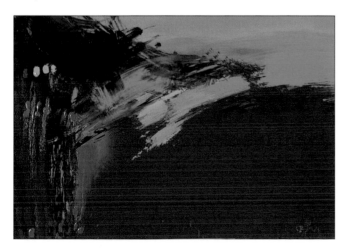

Adding the final touches

To soften the blue and the red, I dragged some darker Hooker's green into this central area, breaking it up slightly on the left side. I finished the reds by brushing them back into the green, and did the same to put the blues back into the detailed greens. Finally, I put on some random marks with the darker green in the initial tree area (established in Step 1), both to give a sense of order and to introduce additional areas of interest as the painting approached completion – and at this point I became very conscious of the danger of working the painting to death!

Poppy Field
Mixed media on cotton canvas
76 x 61cm (30 x 24in)

As was the case with *Lavender Fields* (*see page 48*), I began with the intention of maintaining a strong visual link to the original scene with, in this case, the use of vibrant reds and greens to provide a celebration of colour.

With its unequal areas of complementary colours, the overall effect of the painting echoes the work of some of the Post-Impressionists (Derain, for example, very often used thin layers which were built up, and had a strong use of complementary colours) and follows a tradition that stretches from Matisse through to Hodgkin and beyond.

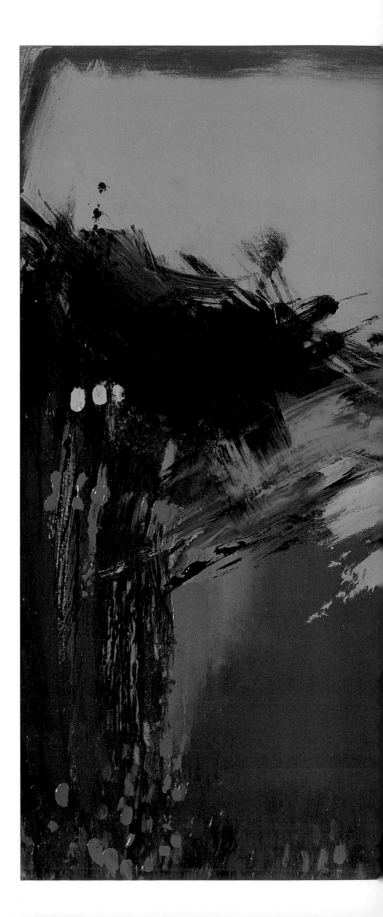

Quayside

Acrylic

Small harbours and fishing boats are perennially fascinating subjects for artists, as they present such wonderful contrasts of frantic, colourful activity juxtaposed with large areas of tranquillity and calm.

This scene at Wells-next-the-Sea, Norfolk, is a classic example of this and, as such, is a good opportunity to use the Post-Impressionist style of approach. I decided to change the views from the photographs slightly for the painting itself, as I felt a different angle would help the perspective and improve the overall composition.

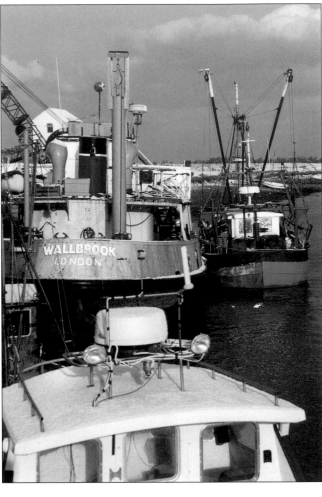

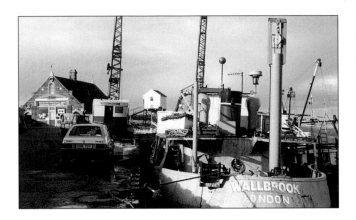

(above) **Quayside scene**

These photographs of the quayside show an old dredger and pilot boat moored alongside a museum, which was formerly an old lifeboat house. Even without bright sunlight, the bright colours and reflections were perfect for the painting.

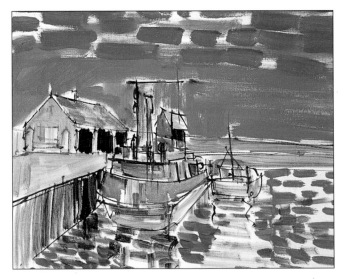

(left) **Preliminary study**

In this first painting, I concentrated on getting the angle of the viewpoint correct, and just suggested the basic colour range throughout. Once I felt happy with these factors, I could then move on to starting the more detailed and finished painting.

Step 1

Setting the composition

Using a soft pencil, I divided the canvas into 15cm (6in) squares to help me fix the composition and perspective accurately. Then, using a No. 6 watercolour brush and a mix of burnt umber, cerulean blue and cadmium yellow, I drew in the main elements of the composition in a series of straight or broken lines. I next blocked in some area of colour with a No. 6 bristle brush.

I also applied some blue into the sky area with a No. 12 flat bristle brush in a series of criss-cross dabs or marks, to help me judge the tone and strength of colour I was after for this part of the painting.

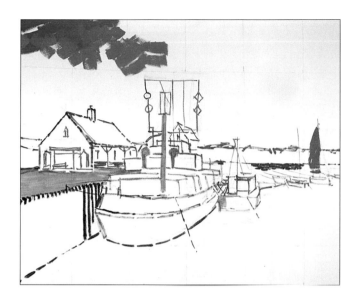

Step 2

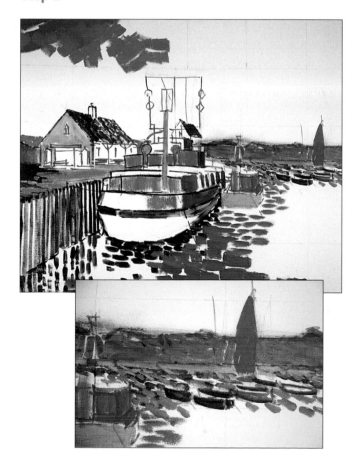

Testing the colours

Using a No. 6 watercolour brush, I painted in the sea wall with a fairly thin mix of burnt sienna, and then used the same brush to paint the gable end of the building and the small boat in cadmium yellow. Turning my attention to the building, I applied a few strokes of ultramarine blue and then overlaid burnt sienna to some parts of the roof to test the depth of tone. I then painted the quayside with a combination of purple and yellow ochre.

On standing away from the painting, I decided that I would change the loosely applied purple of the horizontal band of distant trees, as this was not the colour I wanted; I overpainted the area almost immediately with viridian green (see inset).

Next, I painted the yellow ochre path between the tree line and the sea, and then, using ultramarine blue and violet mixed with titanium white, I started to paint the foreshore under, and into, the yellow path.

See Adventurous Painting Techniques

| Painting Acrylic Washes | **page 14** |

Step 3

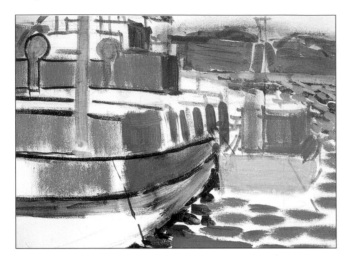

Adding reflections

Changing to a large No. 12 bristle brush, I used a mixture of horizontal and vertical strokes to paint some dark reflections under the quayside wall and hull of the large boat, using a mix of burnt sienna and ultramarine blue.

Keeping to the same brush and using a combination of cerulean blue and cobalt blue, I painted some large horizontal dabs (that became smaller as they receded) to suggest the movement of water. I then scrubbed in some of the burnt sienna and ultramarine blue mixture into the foreground boats. Finally, I re-drew some of my original outlines in black, using a No. 3 rigger brush.

Step 4

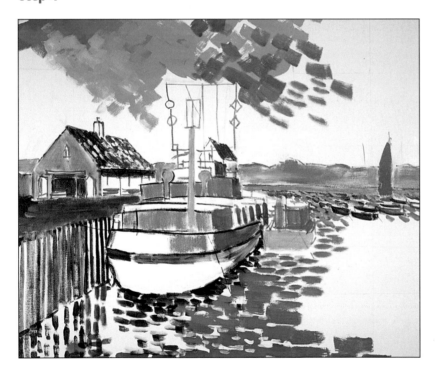

Third thoughts and changes

I next changed the band of trees, which I had already overpainted with viridian green, to violet, which I was much happier with. Knowing that it would be too intrusive for me to simply overpaint with violet, I first painted titanium white over the offending green and allowed it to dry before applying the violet on top. The result is exactly what I wanted, and bears testimony to the versatility of the acrylic medium in troubleshooting situations.

Another change I made at this stage was to the quayside, which I overpainted with cadmium orange – because it is a similar but deeper colour to the original yellow ochre, there was no need to overpaint initially with white. Because the orange is a complementary colour to the blue, it gives more impact. I increased the depth of colour with more yellow ochre on the gable end, the small foreground boat and the pathway under the band of distant trees.

Detail

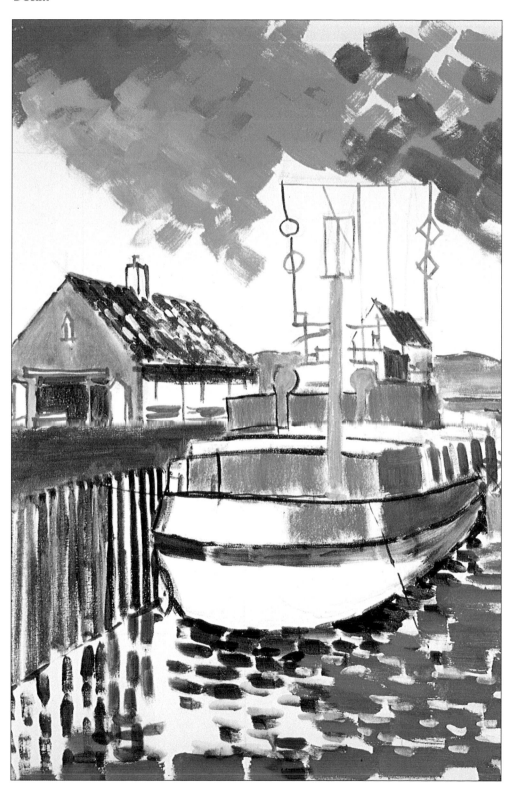

Creating shadows

Using a No. 6 watercolour brush, I began to indicate some reflections using the cadmium orange and yellow ochre, and with the same brush I then loosely painted some shadow areas of the building with ultramarine blue and burnt sienna.

To finish this stage I switched to my No. 12 flat bristle brush and, using light blue and violet separately, each mixed with titanium white, I painted broad brushmarks into the sky area.

Step 5

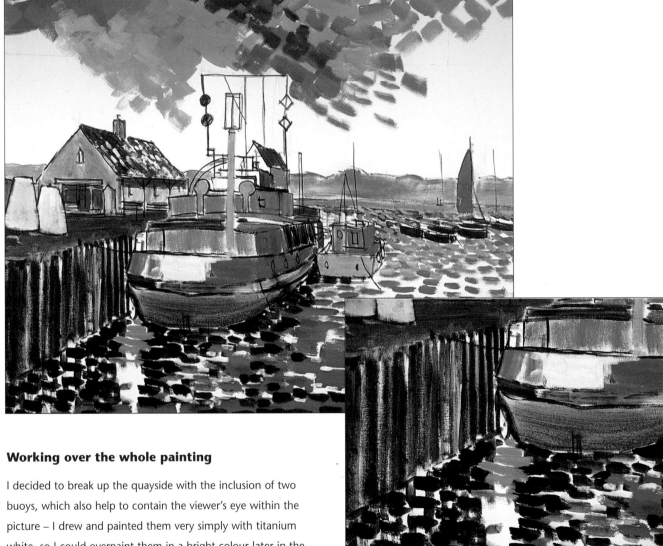

Working over the whole painting

I decided to break up the quayside with the inclusion of two buoys, which also help to contain the viewer's eye within the picture – I drew and painted them very simply with titanium white, so I could overpaint them in a bright colour later in the process. Using the rigger brush, I redrew the basic shapes in black to re-establish the composition; this helps me to see where things are going as the painting becomes more colourful.

I think it is important to develop the painting overall, so no areas get left behind as it were, so I began blocking in more sky to bring this area up to the same development level as the rest of the painting; I used a No. 12 bristle brush to apply varying mixes of blue and violet. Using the same brush alternately with a No. 6 bristle brush, I painted in the large area of water using smaller brushstrokes in the distance: the colours were mixes of cobalt blue, cerulean blue, light blue and violet – all mixed with titanium white. I also used some black and violet to indicate darker areas.

I now felt that the areas of white on the large boat needed to be toned down, so I applied loose washes of burnt and raw sienna to the hull and a soft grey mix of burnt sienna, black and white to the superstructure. I then painted a further loose wash of these same colours on the sea wall to strengthen this area in keeping with its surroundings (*see inset*).

Step 6

Developing the sky

I painted the two buoys with a No. 6 watercolour brush, one viridian green and the other cadmium red. Next, I painted another layer of cadmium orange over the quayside, this time mixed with titanium white, to provide increased depth of colour.

For the sky area, I prepared separate mixes of cobalt blue, cerulean blue and light blue, all mixed with titanium white, plus violet and alizarin crimson, and violet, both with titanium white

with a very small amount of yellow ochre. I continually adjusted these mixes as I went along, adding more titanium white, which helped to indicate fluctuations of light within the sky. I then began to mirror some of the sky colours into the water, using the No. 12 bristle brush – the brushmarks in the sky were varied in direction, whereas I painted the reflection marks in the water uniformly in horizontal strokes. I blocked in more colour on the boats, using titanium white with a touch of yellow ochre, viridian green, cadmium orange and cadmium yellow.

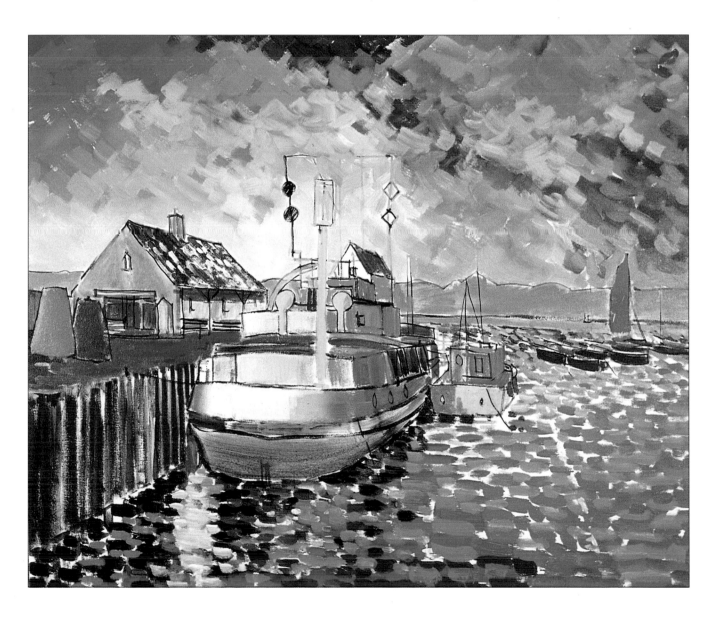

Step 7

Reflecting colours

Using the No. 6 watercolour brush, I lightened the pathway under the horizontal band of distant trees with a mixture of yellow ochre and titanium white, and then painted horizontal brushstrokes on the gable end, to add texture to the building and suggest its sandstone construction.

I put more detail into the water, using a No. 12 flat bristle and a No. 6 watercolour brush with cobalt blue, cerulean blue, light blue and turquoise green, all mixed with titanium white at varying strengths. I also used some black on its own to give depth under the boats and sea wall. While doing this, I gave some consideration to reflecting the colour in the sky: I was not looking for the kind of accuracy needed in a representational piece of work, but felt it was still important. You can see this where the original white of the canvas shows through and adds sparkle.

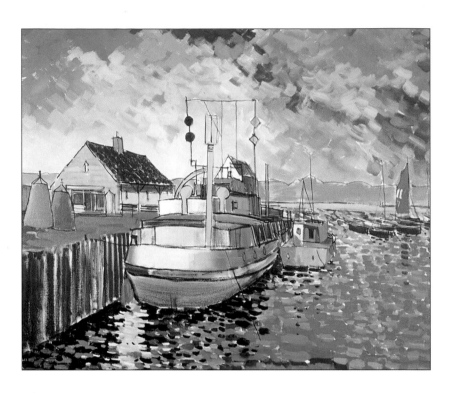

See Adventurous Painting Techniques

| Painting Acrylic Washes | page 14 |

Step 8

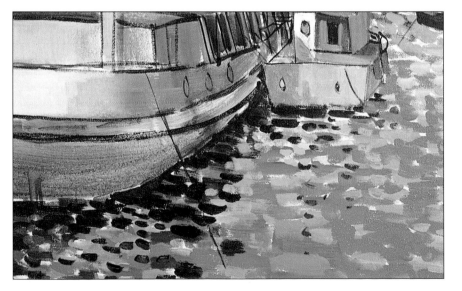

Reinstating outlines

I now decided to increase the modelling on the boats to create more form, and achieved this by blocking in various colours with a No. 6 watercolour brush, following the natural line and form of the boats themselves.

To finish this stage of the painting, and as a prelude to the final stages, I reinstated many of the original outlines in black, using this as an additional opportunity to redefine the basic shapes within the overall composition.

Step 9

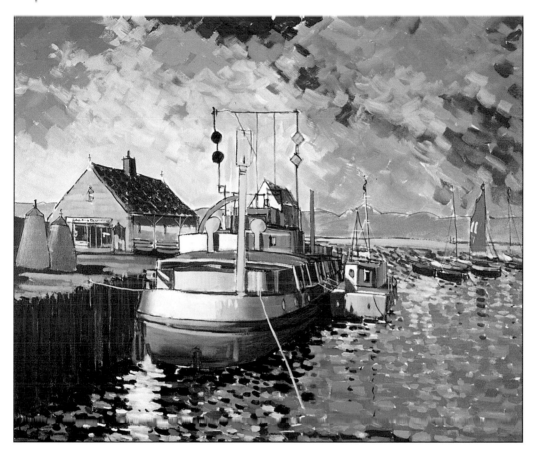

Bringing it all together

I lightened the sky area on the left-hand side using a No. 12 flat bristle brush loaded with titanium white with a little light blue added. At this stage I noticed, and was unhappy about, the lack of light on the quayside, so I painted over most of this with a lighter cadmium orange that included a little cadmium yellow. I then put the final colours onto the two quayside buoys and painted some purple shadows using a No. 6 watercolour brush. While working in this area, I added final details to the building using the same brush and a No. 3 rigger.

I darkened the sea wall using the same watercolour brush, with a combination of ultramarine blue, burnt sienna, purple and black, using greater amounts of black where the wall meets the sea.I completed the sea area using the No. 12 flat bristle brush with a mix of titanium white with some light blue added; I switched to the No. 6 watercolour brush to make smaller marks. I also added more marks to represent reflections where necessary, using the boat colours.I then painted more detail onto the boats: this included incidentals such as mooring ropes, portholes and so on. Finally, I strengthened the shadows and increased the intensity of the lights to add greater contrast and impact.

Quayside
Acrylic on primed cotton canvas
91.5 x 76cm (36 x 30in)

The subject of this painting, the quayside in my home town, is ideal for working in the style of the Post-Impressionists, because of the opportunities presented by ripples and reflections. These allowed me to build up the overall image using small, individual dabs and brushmarks of colour.

The end result is a riot of vibrant colour which was a lot of fun to paint. The use of complementary blue and orange, in their purest form, helps the design, as does the use of strong, busy areas of activity against quiet areas of single colour.

I deliberately made the smaller foreground boat the brightest part of the painting, to avoid total domination by its much larger partner. Including the smaller sailing craft helped me to balance the composition.

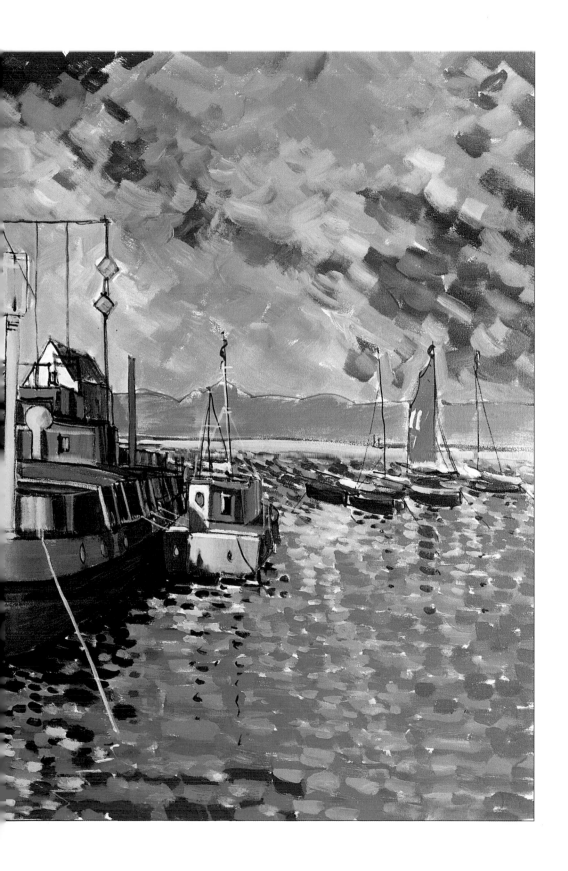

Birchwood

Oil

The idea of treating this type of dense woodland scene in a late-Impressionist style is one I have visited a number of times. All the versions I have painted contain a feeling of stillness and strength, conveyed by the very strong vertical tree shapes.

Having decided that there would be no central focal point of interest in the composition itself (*see the sketch below*), I decided to approach the painting in a bold, adventurous way, both in terms of the shapes and the use of colours: while these were exaggerated to achieve the emotional effect, I wanted to keep them in harmony throughout.

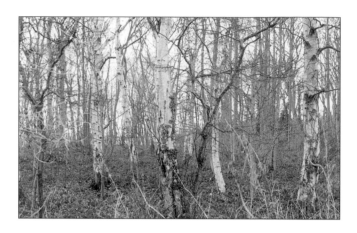

Finding lines

The strong visual pattern of hard and soft lines and shapes suggested itself to me when I was driving through wooded countryside – this photograph is a typical view.

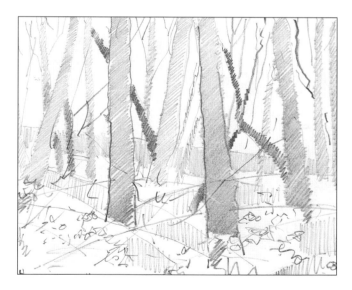

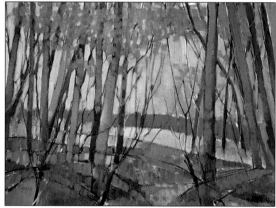

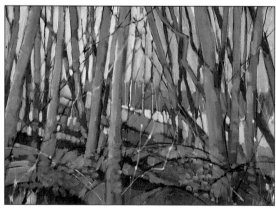

Choosing a viewpoint

I wanted to create the feeling that the viewer is looking at a small segment of a much larger scene. To this end, I purposely avoided including any central point of interest which would draw the eye, at the expense of the whole.

(right and right above)
Subdued studies

The two paintings shown here are much smaller than the eventual project painting, and were produced in quite quick succession before the project. They are much tighter in tone and quieter in terms of colour.

Step 1

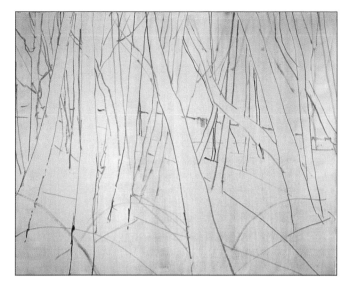

Step 2

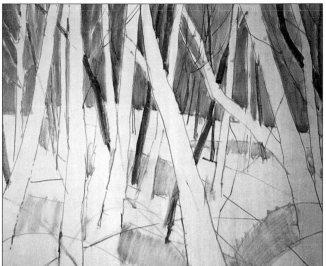

Laying down a base colour

To start, I made a thin base mix of cadmium orange with a little cadmium red and a small amount of thinners and gel medium, and then applied this to the canvas with a flat 2.5cm (1in) watercolour brush. This particular colour is a complementary base upon which to work, so that any areas I then allowed to show through in the final painting would give a vibrancy to the other colours.

I left this overall base wash to dry for a couple of hours; it was not necessary for it to be absolutely bone dry, but similarly it would have been impossible to proceed to the next stage when it was still very wet.

Establishing tree shapes

In order to avoid possible problems with a complicated subject and composition, I decided to do a preliminary study to sort out where I wanted the strong tree shapes. I then transferred this layout to my canvas with a thin mix of ultramarine blue and burnt sienna, which I drew on with a No. 4 watercolour rigger brush. Using this same mix, I then blocked in five or six tree shapes which helped me to keep a clear idea as to the direction I wanted things to go.

I then mixed some more cadmium orange and cadmium red with thinners and gel medium, and painted this in between the tree shapes at the top to form the sky area, and then to block in some of the middle and foreground areas, keeping within the established shapes.

See Adventurous Painting Techniques

| Painting with Oils | page 17 |

See Adventurous Painting Techniques

| Using Oil Mediums | page 18 |

Step 3

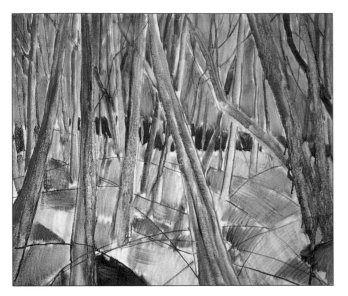

Blocking in the underpainting

I blocked in the remaining tree shapes, first with ultramarine blue and then cobalt blue, using a No. 6 bristle brush for the smaller trees and a No. 12 for the larger ones. I applied the wash thinly and allowed it to run.

To maintain a tonal balance as the painting developed, I blocked in the remaining areas of the underpainting, applying a strong horizontal band of purple, made from a thin mix of ultramarine blue and alizarin crimson, to represent the distant trees.

While I was finishing this stage, I became uneasy with the composition and decided to increase the number of trees in the distance before allowing the painting to dry.

See Adventurous Painting Techniques

| Painting Oil Glazes | **page 18** |

Step 4

Foreground shapes

To paint the remaining foreground shapes, I made varying shades of green: these were mixes of ultramarine blue and cadmium yellow, ultramarine blue and raw sienna, and cobalt blue with cadmium yellow. Where I overpainted my thinly drawn lines with these mixes, I then redefined them.

Step 5

Adjusting the tones

Next I used a No. 6 bristle brush to apply a mix of violet and ultramarine blue with some titanium white over the middle horizontal band on the distant trees. I took care to paint only between the strong verticals of the middle distance and the foreground tree shapes.

Turning my attention to these strong verticals, I painted thin mixtures of violet, viridian green and ultramarine blue, with thinners and gel medium added, to give a darker tone across the painting to help with the on-going harmony and avoid any one area becoming intrusive too soon. To re-establish the original drawing I repainted all the lines and outlines, applying a thin mix of ultramarine blue and burnt sienna with a No. 4 rigger brush.

To help me establish in my mind's eye how the painting might develop from here, I painted some thick brushmarks of purples and greens into the foreground segments.

Step 6

Developing the sky

Using a No. 8 watercolour brush I blocked in the sky with a mix of Naples yellow, titanium white and a small amount of cadmium orange. Working from left to right, I gradually introduced some cadmium red to the mix as I progressed, and left small amounts of the original base colour unpainted – this showed through to help the sky area to glow.

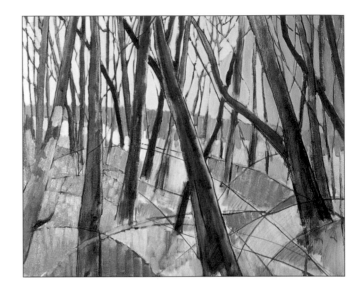

Step 7

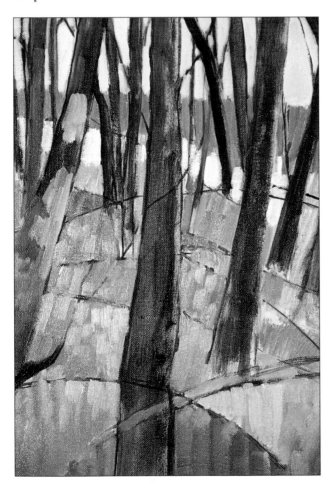

Maintaining the balance

In order to develop the painting in a balanced way between the foreground and background, I turned my attention to the foreground area. To show this stage, I concentrated only on the left-hand side. Working between the strong tree shapes, I applied small vertical marks using washes of light red, viridian green, viridian green with cadmium yellow, violet, cadmium orange with light red, and Naples yellow in varying strengths, with titanium white and a small amount of thinner, laying one No. 6 bristle brushstroke over another.

To finish this stage I laid in ultramarine blue and titanium white, and cerulean blue with titanium white in varying strengths in the strong foreground vertical tree shapes on the left-hand side only.

See Adventurous Painting Techniques

Painting with Oils **page 17**

Step 8

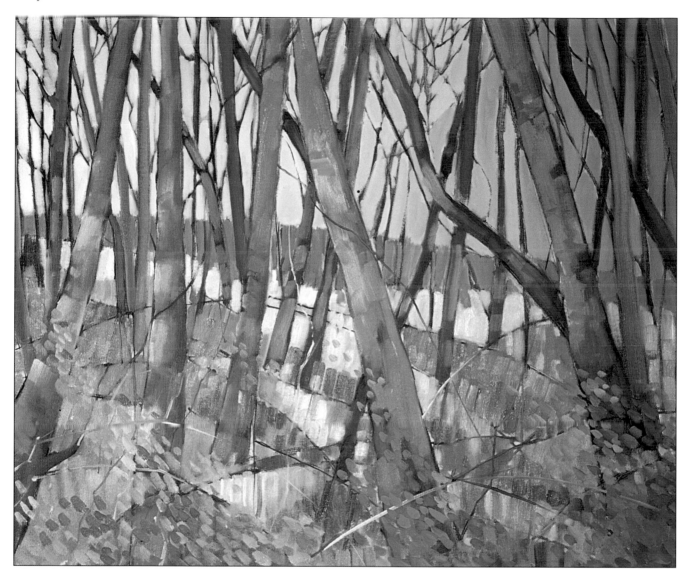

Adding greens

I softened some of the small vertical marks with a large, clean bristle brush. I also continued to block in the vertical tree shapes with the same blue mixes I had used previously – blending in some places and leaving straightforward marks in others. While these foreground and tree marks were still wet, I mixed three separate greens, using viridian as the base colour in each, adding cadmium yellow and varying amounts of titanium white, and then applied these with a No. 6 watercolour brush in small dabs in the diagonally opposite direction to the marks previously painted. I then left the painting to dry.

See Adventurous Painting Techniques

Blending Oil Paints	page 19

Step 9

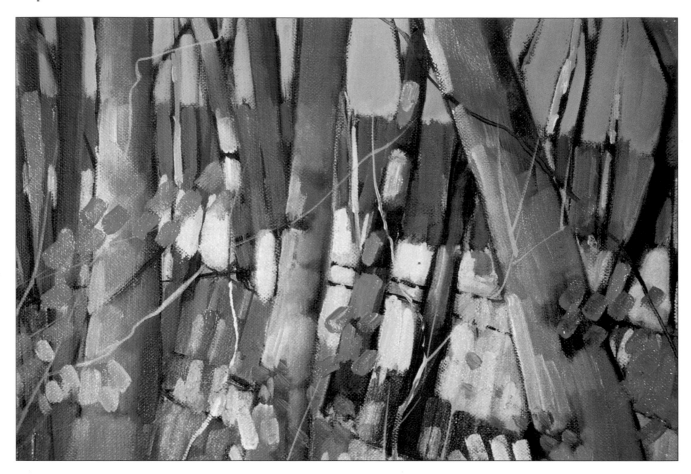

Introducing variety

In the final stages I wanted to add more light to the middle and foreground area: with the exception of some work on the vertical tree shapes, I concentrated solely on the area below the purple band representing distant trees. Using a No. 6 watercolour brush and a mixture of Naples yellow and titanium white, I lightened the horizontal band just below the distant trees.

I then overlaid various colours in the foreground area, alternating the No. 6 with a No. 4 flat bristle to achieve different types of mark. This application was particularly varied and random, and the colours, which were all mixed with varying amounts of titanium white to give me the light I wanted, were viridian green, cadmium orange, violet, cadmium yellow and Naples yellow, applied in similar dab-shape marks across the foreground.

See Adventurous Painting Techniques

Brush Techniques　　　　　　　　　　　　　　　　　**page 22**

Detail 1

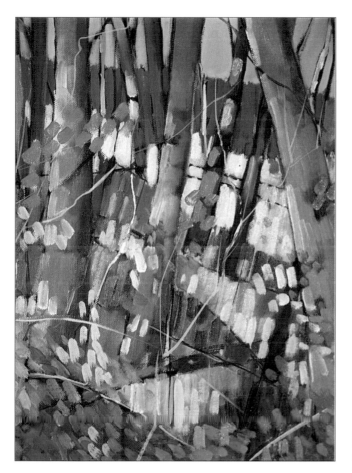

Detail 2

Adding the light

I now wanted to introduce the lightest element of the painting, which would be the effect of very thin twigs and undergrowth. I painted this in titanium white using a No. 3 rigger brush.

Because I had used an orange colour for the base, I decided to retain much of the blue in the strong tree shapes; being the complementary colour of the orange, this would help to give a vibrancy to the finished painting. I reinforced the blue using a combination of cerulean blue and violet mixed with titanium white, applied with a No. 6 bristle brush and No. 6 watercolour brush to achieve a variety of marks.

Harmonizing the movement

To increase the feeling of movement and energy in between and over the pillar-like, cool blues, I painted more leaf shapes using the No. 6 watercolour brush with varying mixtures of viridian green, cadmium yellow and titanium white.

Finally, to harmonize the painting by re-introducing the colour used as a base at the beginning, I reinstated the orange colour in the foreground area and sky area with some additional leaf shapes.

Birchwood

Oil on cotton canvas

61 x 51cm (24 x 20in)

By creating the idea of the painting itself being a small part of a much larger piece of landscape, I attempted to give the viewer a strong feeling of actually standing in amongst the undergrowth – the treatment of the trees, that leave the painting at the top of the canvas, supports the feeling of close proximity. To emphasize this, I painted four very strong tree verticals going out of the picture at top and bottom – in fact, all the trees are taken out of the painting at the top. The central horizontal band, depicting distant trees, also leaves the painting on both sides of the canvas.

The patterned foreground is created by indicating brambles curving across the viewer's path, and this suggests how we see through dense woodland, the tall bramble branches criss-crossing each other, creating strong segments of colour within. To follow this idea through, I included quite a lot of colour and activity in three corners and around the edges, to make it easy for the viewer to imagine continuity on a much grander scale.

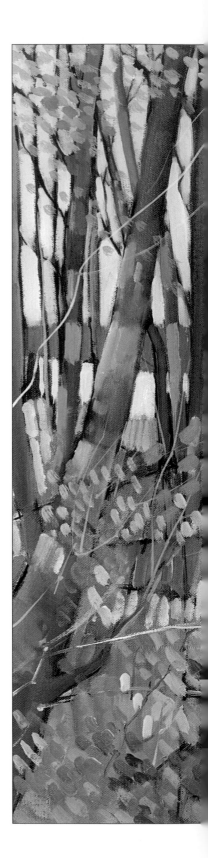

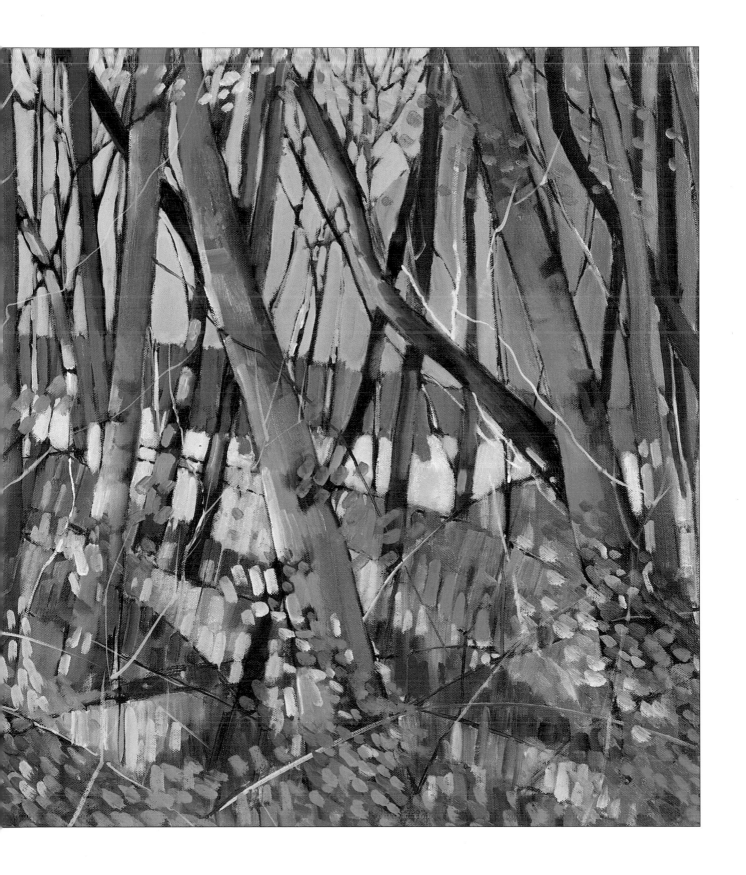

Hunstanton Cliffs

Mixed media

This painting is based on coastal cliffs at Hunstanton in Norfolk, which I very often visit when I take students painting in the summer. So that they can finish their paintings on the spot, these visits are always made on warm, bright days – but I am also familiar with the scene in misty, overcast conditions and, very occasionally, heavy rain.

When I set about this painting I wanted, as much as possible, to encapsulate all the various indefinable feelings I had about the place in all its moods. Right up to the point I began to paint I was still quite uncertain how best to tackle the subject, but decided to let things develop on the canvas and make necessary adjustments as I went along.

(left) **Choosing the format**

To begin with, I produced a sketch over which I quickly applied some watercolour to re-familiarize myself with the subject. My initial layout was in landscape shape, but for the painting itself, I chose portrait shape – this was to give the viewer the sense of space leading up to the cliffs, rather than the space on either side. The area at middle right, suggesting the sea, was indicated only, as I believed it to be less important to the surrounding space from which the viewer sees the painting.

(right) **Atmosphere through colours**

Having done my sketch, I decided to produce some quick colour studies to expand some initial thoughts and ideas. I wanted to include the cliff shape within the feeling of wide open space but didn't want it to appear too hard or overpowering, so I decided to go for a softer impression in the Rothko style, using bright colours but with a soft, atmospheric, hazy feeling.

Step 1

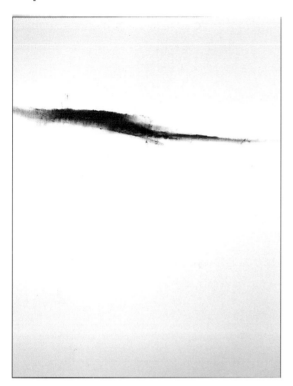

Step 2

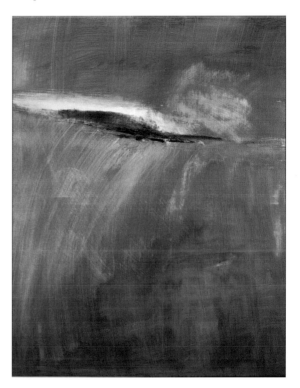

Establishing the focus

I carefully considered the composition with regard to the feeling of space I wanted to generate. I decided, therefore, to place my main focus of interest on the top third line, which would give me the feeling of depth I wanted by leading the viewer into the painting. Compositionally, placing key objects on the 'thirds' is more interesting than placing them in the centre, as it splits the space up in a far more interesting way.

In order to provide texture which I could subsequently overlay with acrylic, I used ultramarine blue, Mars red and raw umber oil bars to establish the base colours of my focal point – the meeting point of the cliffs and the sea. The Mars red was applied in varying degrees of thickness, and I then blended it very gently across with my finger.

See Adventurous Painting Techniques

Painting with Oil Bars	page 20

Applying the first wash

In order to achieve a warmth that would glow through in places in the finished painting, I used 2.5cm (1in) and 4cm (1½in) decorator's brushes to apply a thin acrylic mixture of cadmium orange, cadmium red and burnt sienna over the entire canvas. While this wash was still quite wet, I gently rubbed over the entire surface with a damp cotton rag to blend and remove some of the paint. Then, when the paint was nearly dry, I took a clean damp cloth and rubbed harder in areas adjacent to the initial Mars red area to remove some more paint. Finally, I rubbed harder still to expose, as best I could, the white of the canvas; this brought a feeling of a chalk face to my imaginary cliff area. I then reinstated some of the oil-bar work where I had rubbed with the cloth.

See Adventurous Painting Techniques

Painting Acrylic Washes	page 14
Removing Acrylic Paint	page 15

Step 3

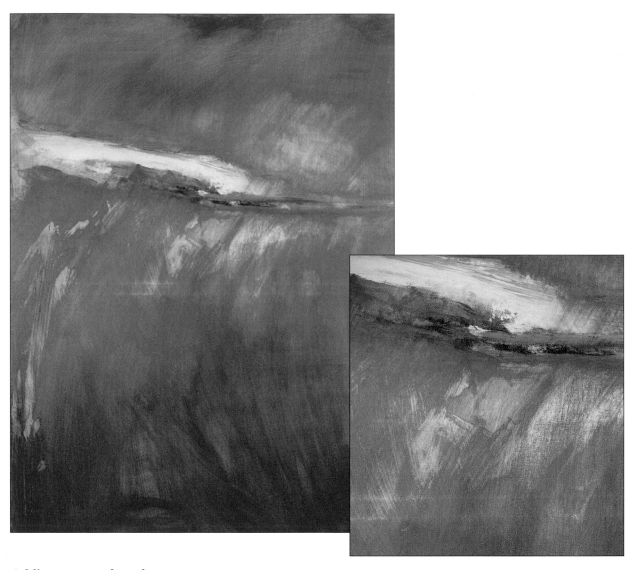

Adding a second wash

At this stage I decided that the white area just above the Mars red needed toning down, and I used a blue-violet mixed with white, painted on very loosely, to achieve this. I next applied emerald green and cobalt blue, both mixed with white, to the adjacent areas. With the exception of these areas, I then repainted the entire canvas with a wash of the original base colour and rubbed to remove it in part as before; this gave a greater density of colour, covering some of the underpainting in parts.

Before moving on, I added some cadmium yellow to the mixture and applied this to the upper part of the canvas to the right of the Mars red – the cliff area. I used a slightly thicker mix for the bottom left- and right-hand sides; when this was nearly dry, I rubbed it with a damp cloth to form hard-edged textured areas (*see inset*).

See Adventurous Painting Techniques

Creating Acrylic Textures	page 16

Step 4

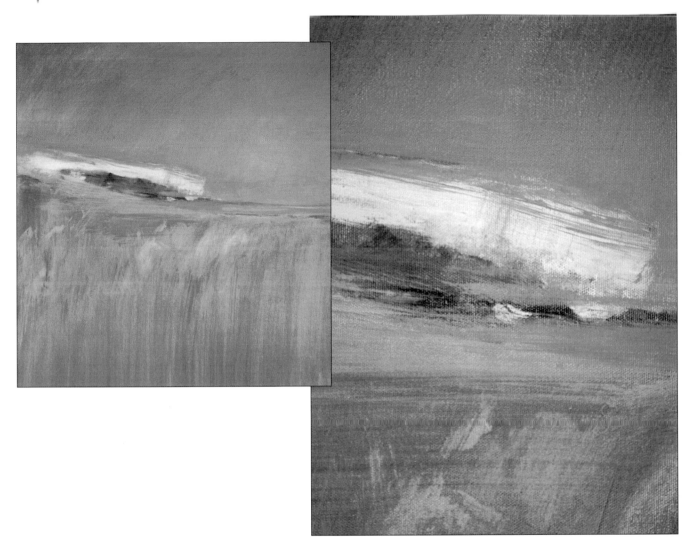

Adding warmth

Having made the decision to create a warm foreground as a foil for the blue in the top third of the painting, I applied Naples yellow with a 4cm (1½in) decorator's brush. I allowed a short period of drying time and then proceeded to rub back everywhere with a damp cloth to maintain a translucency which would help the base colours to show through.

For the blue I loosely applied a mixture of ultramarine blue, cobalt blue and white, and then dragged this with the brush into the emerald green and Mars red focal area. I added a loose, thin brushload of the same blue around the edges of the warm foreground area to emphasize the contrast between the two colours, and to represent the atmosphere I sought: an overall soft feeling of space, as opposed to stark, hard contrasts (*see inset*).

See Adventurous Painting Techniques

| Painting Acrylic Washes | page 14 |
| Removing Acrylic Paint | page 15 |

Step 5

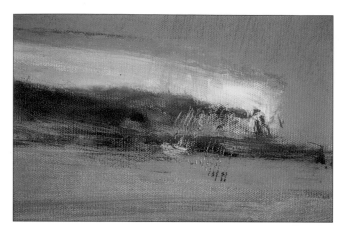

See Adventurous Painting Techniques

| Creating Textures | page 24 |

Step 6

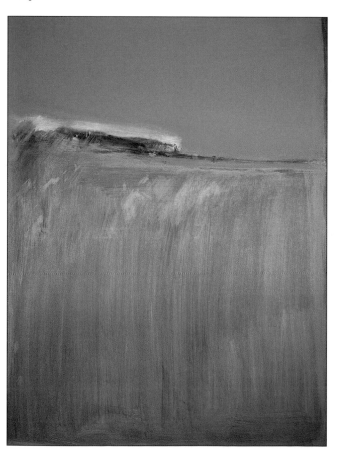

Emphasizing the focal point

I added a border of Mars red oil bar to create a frame that holds the composition in (*see Step 6*). This enhances the effect of pulling the viewer into the painting, by incorporating detail and texture. I then redefined the focal point, working in acrylic and oil bar with the colours previously used. This was a delicate process during which I was careful not to overwork any one area, blending small parts with the tip of my finger.

Where I applied acrylic over oil bar in the focal areas I scraped through quite randomly with the edge of my palette knife. This created a texture that I had the option of retaining in the final painting – if it was not required, I could always overpaint it at a later stage.

Stepping back

At this point, I decided to stop and re-establish in my mind just what I was trying to convey with the painting – the central theme or meaning can sometimes be lost as the process almost takes over. In this case the feeling I wanted to convey was one of space, and I wanted the painting to be soft and atmospheric.

With this in mind, when I added a further thin layer of cobalt blue and cerulean blue mixed with white, I painted down into the focal point and took the same colour, in the same strength, around the border.

Step 7

Step 8

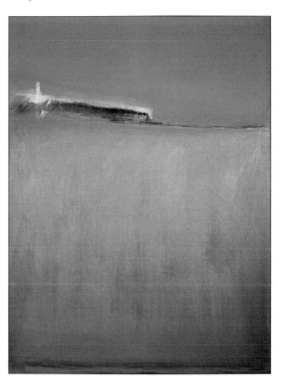

Varying the thickness

I cannot over-emphasize the importance of overlaying colours in different thicknesses and varying the pressure with which the paint is applied, to give an inconsistency of coverage that helps to add interest. I used this technique to apply a border of Mars red oil bar over which I painted raw sienna oil bar.

I turned to the focal area again and defined the lighthouse with unbleached acrylic titanium. I applied small amounts of the same colour into the surrounding area and along the horizon line, using the paint very gently on the end of my finger. With the 2.5cm (1in) decorator's brush I applied viridian green acrylic mixed with white to the top and left-hand side of the focal area, and took this thinly over the left-hand border to the bottom.

See Adventurous Painting Techniques

| Painting with Oil Bars | page 20 |
| Painting Acrylic Washes | page 14 |

Strengthening the foreground

I now concentrated on the bottom two-thirds of the canvas, which represents the foreground in the composition, by painting on a quite thin acrylic wash of Naples yellow mixed with a small amount of cadmium orange, using the 2.5cm (1in) decorator's brush. As I neared the blue border, I blended some of the mixture with some of the blue I had previously used for this part, using very light, feathery brushstrokes to achieve a soft, misty feeling. I did, however, leave some hard, unblended edges at the bottom of the painting.

It is important to note that the original orange base is still visible everywhere at this stage, including the top third, blue area.

See Adventurous Painting Techniques

| Blending Acrylic Paint | page 14 |

Step 9

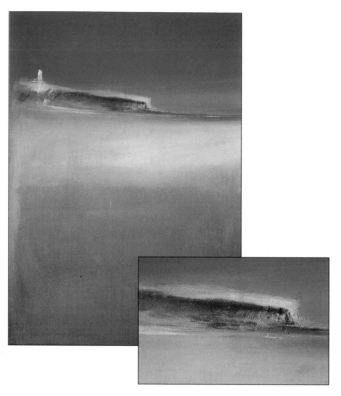

Step 10

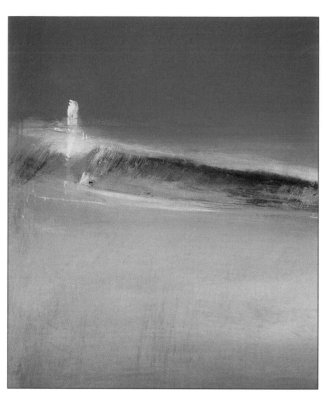

Creating depth

I now wanted to create more depth, and painted the sky area a darker blue using a mixture of cobalt blue, purple and white acrylic with the 4cm (1½in) decorator's brush. I immediately softened the top and bottom of this area by wiping with a damp cloth; this allowed the original blue to show through, and helped to make the area more interesting.

I overpainted the foreground with a mixture of Naples yellow, cadmium yellow and white, and brushed the thicker paint on the right-hand side over the border to give a feeling of movement. I immediately softened the top edge by wiping it with a damp cloth. Adding some more cadmium orange to my mix, I applied thinner areas of colour to the middle foreground, blending these into the surrounding areas of colour and brushing out towards the borders and into the yellow I had just applied (*see inset*).

See Adventurous Painting Techniques

| Creating Acrylic Textures | page 16 |

Adding details

I reinstated the lighthouse using unbleached titanium white, and then changed to a fine rigger watercolour brush and added more interest by painting very thin lines of the same white, followed by chrome green, into the focal area. All the time I kept very much in mind that the white lines should be used to add interest only in the form of marks – not detailed, representational objects, which would be overstated.

Before beginning the final stages, I stood the painting in my studio where I could see it easily, and spent three or four days looking at it from time to time before deciding how I was going to finish it.

Step 1

Starting the composition

I set out with the intention of keeping my use of colour and tone quite dark and limited. To this effect, I began with a small watercolour brush and drew in the composition with thin lines of Hooker's green acrylic. These were allowed to run in places, and then I worked them with a damp cloth to give some broader areas of colour, which I then left to dry.

See Adventurous Painting Techniques

| Removing Acrylic Paint | **page 14** |

Step 2

Building up washes

Using a 2.5cm (1in) decorator's brush, I applied a random strip of very thin ultramarine blue acrylic wash to the top quarter of the canvas, and immediately wiped this with a damp cloth to achieve a variance of depth.

I then prepared separate washes of viridian green, phthalo green and turquoise (these were not mixed in the palette) and applied these thinly, either leaving them to run in places or wiping them off to expose the canvas underneath (see, for instance, the bright area of viridian green at the top).

See Adventurous Painting Techniques

| Removing Acrylic Paint | page 14 |

Step 3

Using runny washes

In the bottom left-hand corner I applied Hooker's green, leaving some rough brushmarks and a thicker area of colour. I then applied a thin wash of phthalo green immediately above, and allowed rivulets of this to run through the thinner areas of paint below. Using a slightly different approach in the bottom right-hand corner, I added a wash of phthalo green over an already applied one of Hooker's green, and allowed this second wash to run.

Step 4

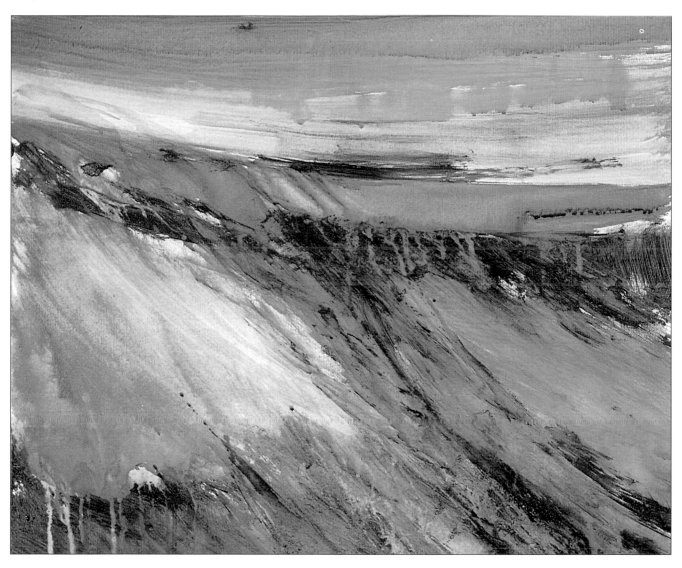

Adding depth

I next repainted the darker areas of Hooker's green more thickly, but loosely, using a 4cm (1½in) decorator's brush; following this, I painted some fine lines using the tip of the same brush with the same colour.

While this was still quite wet, I applied quite thin washes of the three separate greens from Step 2, working over the entire canvas from top to bottom and allowing the washes to run through the dark mix of Hooker's green.

See Adventurous Painting Techniques

Painting Acrylic Washes	page 14

Step 5

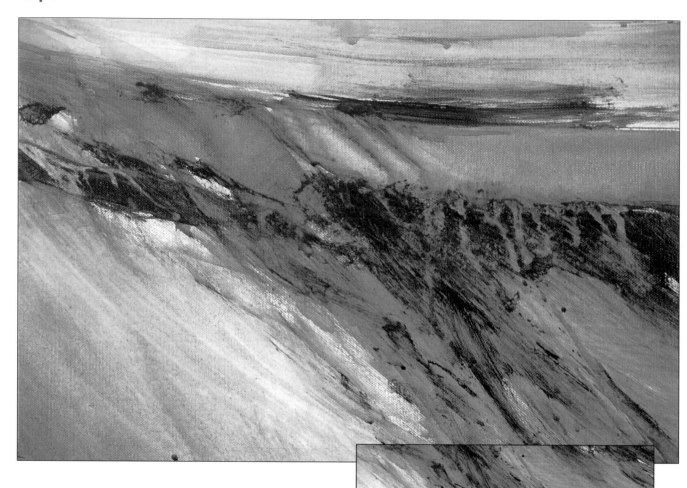

Taking off paint

After allowing time for these washes to begin drying – so that the paint would move relatively easily and, where required, allow me to remove it almost completely – I took a damp cloth and began to wipe the lighter green, middle right- and left-hand sections, using sweeping movements. Using the same damp cloth, I also dabbed the lower right foreground to convey flowing movement in the middle section and a wave texture in the lower foreground area.

Once the washes were dry, I spattered phthalo blue in the foreground area to finish this stage (*see inset*).

See Adventurous Painting Techniques

| Removing Acrylic Paint | page 14 |
| Spattering Paint | page 23 |

Step 6

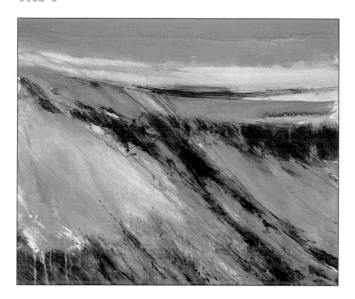

Smoothing the texture

To counteract the textured areas and produce some flatter parts, I decided to introduce titanium white to my colours, being careful not to add too much as this would result in an unwanted, chalky, opaque effect.

I painted a mixture of ultramarine blue and titanium white in a horizontal band towards the top of the canvas to depict a feeling of cold, followed by a slightly thinner wash of the same mix applied to the middle left-hand section to echo the previous horizontal application.

Step 7

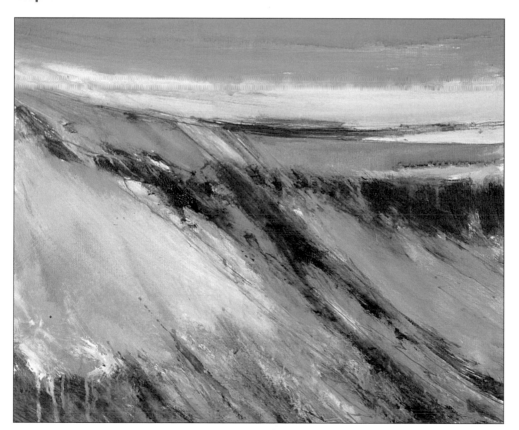

Putting on layers

I next mixed titanium white with viridian and painted this quite thickly across the very top of the canvas to give a layered effect. To follow, I added turquoise to this mixture and applied this thinly with the tip of the decorator's brush, working into the Hooker's green in a random fashion in all areas.

Step 8

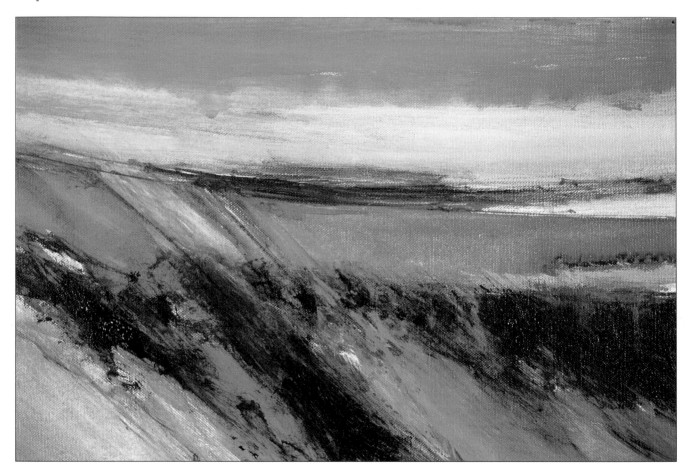

Adding detail lines

I then changed to a watercolour rigger brush and used this
to apply thin lines of Hooker's green to establish a feeling of
detail and add interest; this also helped me define the overall
composition and flow of the painting.

It is worth noting that I avoided painting flat lights over the
darks, preferring to paint light adjacent to the darks, thus
avoiding a milky finish.

Step 9

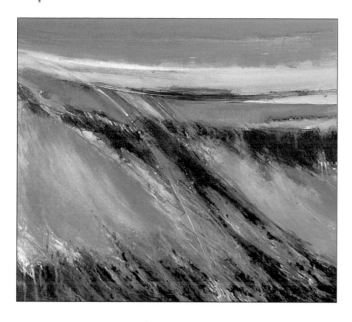

Adding the surf

In this final stage I wanted to indicate surf, but more as an abstract element of the composition rather than in any straightforward, representational way.

I painted thin lines of titanium white mixed with turquoise, using my watercolour rigger brush, and also applied random small marks with the same colour everywhere, with the exception of the top fifth of the canvas. To further lighten the very light strip of the same mix immediately above the top blue horizontal mark, I blended it with the tip of my finger.

See Adventurous Painting Techniques

Creating Acrylic Textures	page 16

Detail

Strengthening the darks

Reverting to the decorator's brush, I used a thin mix of viridian green and titanium white to add more colour to the flat area to the left- and right-hand sides.

Continuing with the same brush, I strengthened the darks at the bottom of the canvas. Finally, I used the same brush to splatter ultramarine blue, phthalo green and titanium white into the foreground to finish the picture.

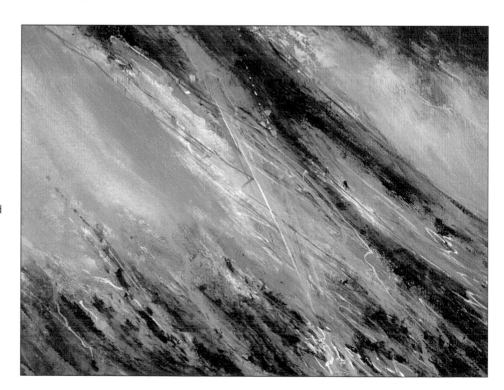

See Adventurous Painting Techniques

Spattering Paint	page 23

Southern Ocean
Acrylic on cotton canvas
61 x 51cm (24 x 20in)

This painting was designed to carry a very definite feeling of disquiet – and, perhaps, some degree of threat or menace.

A viewer who was unaware of the title I have chosen might possibly interpret the subject to be a piece of wild moorland or fast-moving water coming through a weir. Be that as it may, whatever the interpretation, the feeling created is not one of comfort. This underlying feeling of unease is exaggerated by keeping the colour harmony tight (*ie* within a somewhat restricted set of limits) and using primarily dark hues.

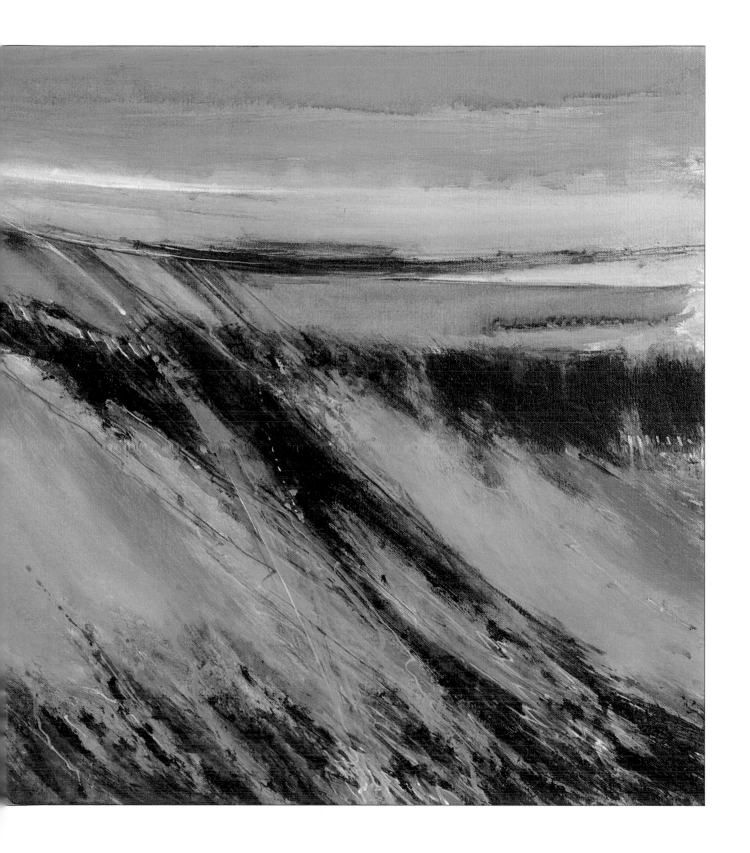

Hope and Despair II

Oil

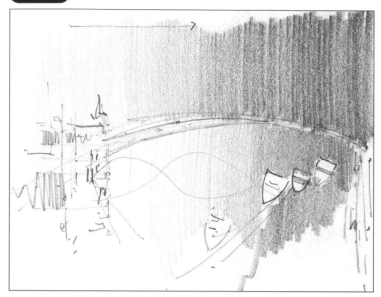

(above) **Dual influences**

In addition to being very familiar with the area of coastline where I live, I also visit North Yorkshire regularly and am quite used to seeing some angry weather conditions in both these locations. In fact, as my initial sketch was taking shape I realized that, although the emotion on which I was basing the painting was tied up in my home coastline, the sketch was being influenced by my memories of the northern area.

This painting is of the same school as *Descending into the Blues* (*see page 116*), in the sense that it doesn't have a particular piece of landscape as a base, and is more an amalgam of many different ones.

The idea upon which the painting is based came to me following the loss of a friend at sea. My objective was to create a very strong feeling of security and calm up against a contrasting area of dark and despair. To a large extent there is a feeling of helplessness and frailty, represented by the boat shapes, with the proximity of my harbour area offering hope – it is a painting of strong emotional contrasts.

(right) **Winter Harbour**

I have included this painting, that I produced a short time before, because it bears some visual similarity, in terms of sentiment, to the feelings and emotions I wished to convey in Hope and Despair II. *The use of dark paint and small detail is very evident in both paintings for exactly the same reasons.*

Step 1

Step 2

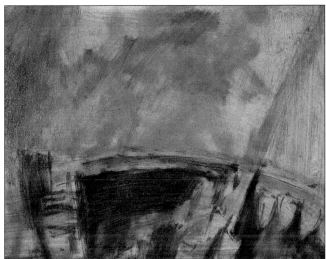

Creating a textured base

Before applying the colour base, I coated the board with a layer of white acrylic primer into which I had mixed a small amount of plaster of Paris. This produced a fairly stiff mix that was just fluid enough to be worked by an old 4cm (1½in) decorator's brush. I was careful to leave obvious rough brushmarks in the primer to give me a textured base – this helped to speed the drying time of subsequent layers of the oil paint I used, and also gave a more interesting effect.

Over this base primer mix, that was completely dry within an hour, I painted a thin acrylic wash of burnt umber mixed with cadmium orange. As soon as I had covered the entire board I wiped it with a dry rag in a random fashion to push the paint into the surface underneath.

Establishing the composition

I drew in the rudiments of the composition with a No. 6 watercolour brush, using a mixture of ultramarine blue and burnt sienna oils mixed with thinner. I decided to keep the detail to the bottom third by indicating boats in the bottom right.

I then used a short, flat No. 9 bristle brush to loosely paint some darker areas with a mix of ultramarine blue and alizarin crimson into which I added thinners and a small quantity of oil gel medium, which speeded up the drying process and added translucency to the colours. To avoid stickiness and a breakdown of pigment, make sure that the gel medium is not stronger than one third of the total mix. I then scrubbed a thin, random layer of cadmium orange over most of the board, strengthening the colour in places with alizarin crimson. Once again, I added some thinners and gel medium to speed up drying.

See Adventurous Painting Techniques

| Painting Acrylic Washes | page 14 |
| Removing Acrylic Paint | page 14 |

See Adventurous Painting Techniques

| Painting with Oils | page 17 |
| Using Oil Mediums | page 18 |

Step 3

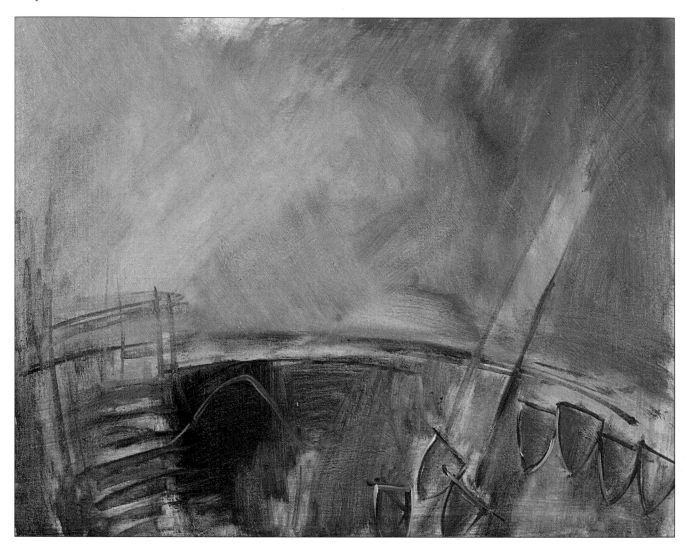

Overpainting the base

I mixed up a wash of cerulean blue with a small amount of titanium white, and a separate wash of ultramarine blue with a small amount of titanium white. Using a No. 12 flat bristle brush, I applied these colours separately to the top areas of the composition, blending them together on the board and leaving large areas of the orange base showing through. I then added a small amount of ultramarine blue and alizarin crimson to the original dark area at the bottom.

To further establish the position of the boats, I used cerulean blue with some oil gel medium, and to add definition I redrew the outlines with a watercolour brush. Using a No. 12 flat bristle brush I applied a mix of cerulean blue and titanium white with some gel medium to the left-hand middle of the painting, setting the position of the lighter areas. In all these washes I took great care not to introduce too much white, to avoid a muddy, chalky result.

See Adventurous Painting Techniques

| Blending Oil Paints | page 19 |

Step 4

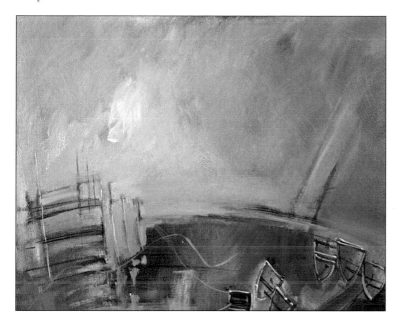

Strengthening lights and darks

I added a little gel medium and a little more titanium white to the mixes in Step 3, and used the No. 12 bristle brush to paint lightly into the top area to develop the lights and darks, with the ultramarine mix on the right and the cerulean one on the left. The light blue area of paint at middle top left was an experimental mark to test colour which I initially intended to brush out; however, I liked the effect of a light area against the orange underpainting and decided to leave it where it was at this stage.

I next added some thin darks with a No. 6 watercolour brush as part of the redefining process (an on-going element of all my paintings): I tend to alternate between order and chaos, with large areas creating chaos followed by small marks re-establishing order.

Detail

Lightening the darks

While I had the watercolour brush in my hand, I decided to paint over some of the dark lines with titanium white – although not all these were retained in the final painting.

To make the slightly thicker marks of blue in the left-hand bottom section between the thin dark lines, or in some cases over the dark lines, I used a combination of the ultramarine blue and titanium white, and the cerulean blue and titanium white mixes from Step 3, applying them with a No. 12 bristle brush.

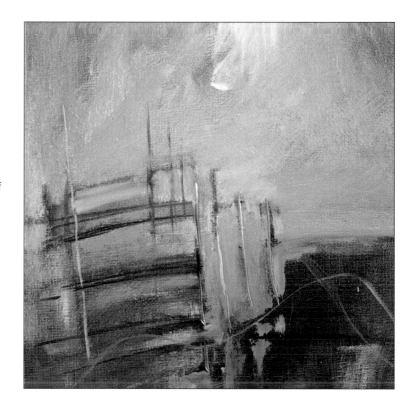

Step 5

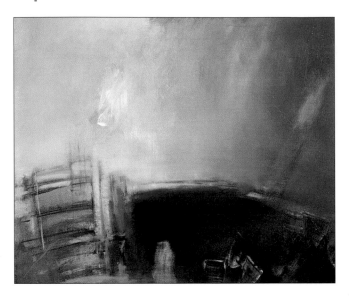

See Adventurous Painting Techniques

| Painting with Oils | page 17 |

Detail

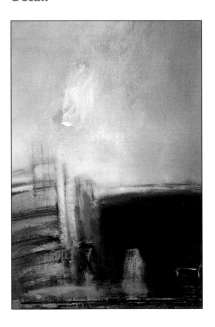

See Adventurous Painting Techniques

| Blending Oil Paints | page 19 |

Adding grey

Having completed the blocking-in stage, during which I sorted out the composition and basic structure, I thoroughly cleaned the No. 12 bristle brush, retaining some of the thinners in the brush itself to keep it flexible. From this stage on, I used thinners only when making detailed marks or thin lines; the reasons were that thinners make paint runny and difficult to control, they eliminate texture, and can lead to things becoming muddy. They also prolong drying times.

With the bristle brush I mixed black with a little ultramarine blue and alizarin crimson, which I brushed out thinly to the bottom centre right to create an area of depression within the painting.

Using the same mix I added further ultramarine blue and a little titanium white, producing more of a grey colour that I painted onto the top right-hand corner, fading towards the left; I took care to allow some of the base colours to show through.

Softening the colours

I introduced some cerulean blue and a little more titanium white to the existing mixture from Step 3, to lighten the colour as I continued painting across the left-hand side. I then made another mix of cerulean blue with titanium white and a very small amount of the orange base colour, which I applied very thinly by brushing out the paint. This allowed even more of the base colour to show through. Still using the No. 12 bristle brush, I gently brushed some of this mix down towards the busy striped area of colour at bottom left.

With a medium-size bristle fan brush I carefully brushed the entire surface of the board, which had the effect of blending and softening the areas of colour I had just applied. In the bottom right-hand corner this produced a misty lost-and-found effect. I left the painting for two days until it was virtually dry.

Step 6

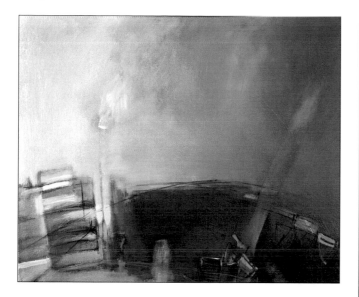

Detail

Applying glazes

Using a No. 6 watercolour brush I added some sweeping, curved lines in black in the central area and, at the bottom of the painting, some straight lines in a mix of cerulean blue and titanium white as a contrast in line and colour.

I now turned my attention to the upper part of the painting, where I wanted to emphasize the effect of light against dark. I mixed four separate colours, each with a little solvent: cerulean blue with titanium white; cadmium orange with titanium white; cerulean blue with titanium white and black; and finally black with cerulean blue, cadmium orange and white. I applied these with a No. 6 bristle brush in the order they were mixed, in equal amounts starting at the left-hand side, blending as I moved across to the right; this glazing technique allows some of the previous colour to show through.

See Adventurous Painting Techniques

| Painting Oil Glazes | **page 18** |

Adding details

Using the first two cerulean blue and cadmium orange mixes, this time slightly thicker, I lightened the bottom left-hand corner, painting into and, in some cases, over the existing colours. To further emphasize this dark area, I glazed the bottom right-hand corner with black and a little solvent.

Finally, to complete this stage, I added some detail and interest to the boat shapes, using ultramarine blue with cerulean blue and titanium white; ultramarine blue and titanium white; and cadmium orange and titanium white – all applied with the No. 6 watercolour brush.

Step 7

Lightening the lights

I decided to further exaggerate the contrast between the light of hope and dark of despair. I didn't want to make the dark area any darker, so decided to lighten the left-hand side, both top and bottom, to achieve the desired result. I used the same light mixes as in Step 5, which I applied with a No. 12 bristle brush, this time without thinners, and blended this back into the existing colours.

This painting is not about broad, bold brushstrokes of colour; quite apart from the relatively small support I used, which doesn't lend itself to bold statements, my intention was to convey a feeling of what it is about in a far more personal or intimate way. This painting is about controlled emotion, and contains quite a lot of small marks and details in a fairly introspective way.

See Adventurous Painting Techniques

Blending Oil Paints **page 19**

Step 8

Adding a rainbow

I noticed two vertical lines that, purely by chance, I had retained on the right-hand side of the painting, and decided to capitalize on the rainbow opportunity they presented. To further develop this idea, I decided to include a suggestion of a glimpsed sun to reinforce the rainbow image.

Step 9

Blending the colours

I applied some further white marks to the lower left with a No. 6 watercolour brush, following which, with the use of a No. 3 rigger brush, I linked the boat shapes across the dark central area with thin, flowing lines of titanium white. To emphasize some of the boat shapes, I also drew in an outline with the same brush.

Finally, using a dry No. 6 bristle fan brush, I very gently blended one area of colour into another, working very gradually across the whole painting.

See Adventurous Painting Techniques

| Blending Oil Paints | page 19 |

Hope and Despair II
Oil on canvas board
46 x 38cm (18 x 15in)

This painting is extensively controlled in the sense that it has quite a rigid structure, albeit one treated in an abstract style. The final result concentrates on small areas of detail in a relatively introspective way.

The simple intention here was to generate a feeling of vulnerability by depicting small objects, in this case little boats, in a potentially desperate situation – some sanctuary being provided by the harbour area.

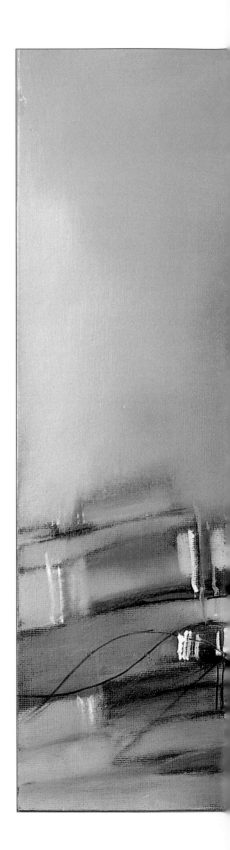

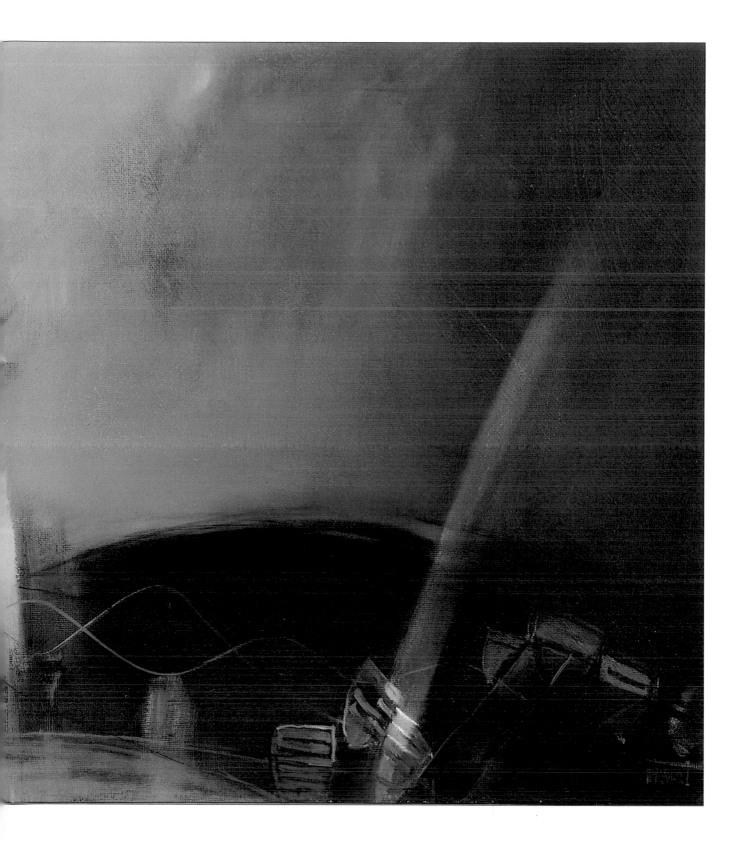

Descending into the Blues

Acrylic

The great majority of my paintings are landscape-based, whether they be representational or abstract. Quite simply, I delight in taking a piece of landscape as the basis on which to develop a painting. Occasionally, however, it makes a refreshing change to work in a completely different way – without a clear idea in my mind's eye as to where the painting is going to go. Just using colour as a means of expressing an emotion or mood is something I find exciting each time.

The title *Descending into the Blues* came into my mind while I was painting; it could just as easily have been entitled *Missing You Terribly*, and if that had been on my mind at the time, that is what I would have called it. The point is that it really doesn't matter very much what the title is; what is more important is whether I feel I have achieved a satisfactory result and conveyed all I want to convey in the painting.

The two paintings on this page have been chosen for their pure abstract qualities, and are the results of enthusiastic application of colour. Only after the initial stages did the titles come to me, perhaps calling upon my memory of things I like.

Just a Passing Fancy
Here is a slice of landscape with a clearly defined horizon separating the sky and the land, drawn together with strokes of blue and foreground flowers. It depicts all that I like in the English landscape and was just a passing fancy of mine – nevertheless line and form play a major part in the composition.

Strawberry Fields
This could have been another field of poppies, but there is so much more going on that represents the bustle of strawberry picking. The overall design and colours are important factors here.

Step 1

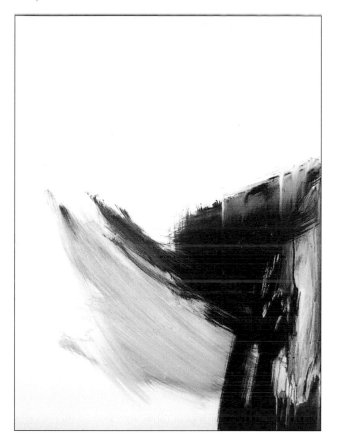

Detail

Applying the first washes

To begin with I decided to get some strong earth colours down, letting the white of the canvas show through in parts. Using a 5cm (2in) decorator's brush I painted a thin mix of raw sienna down the right-hand side and immediately added a loose wash of burnt sienna around and into it, taking care not to overwork this so that the brushstrokes would remain obvious.

With the same brush and the burnt sienna I applied a much thinner wash to the centre section and, with a damp cloth, immediately wiped over it in the direction shown.

See Adventurous Painting Techniques

| Painting Acrylic Washes | page 14 |
| Removing Acrylic Paint | page 14 |

Strengthening the washes

I then applied a strong black wash, separating the two initial areas of earth colour to create a bold visual impact. Some areas were applied very thinly, and I allowed these to run through the thicker paint to add texture, giving me the option of retaining them in their original form if I was likely to require them at subsequent stages – the criteria for this were the shapes and the impact of the colour contrast.

Step 2

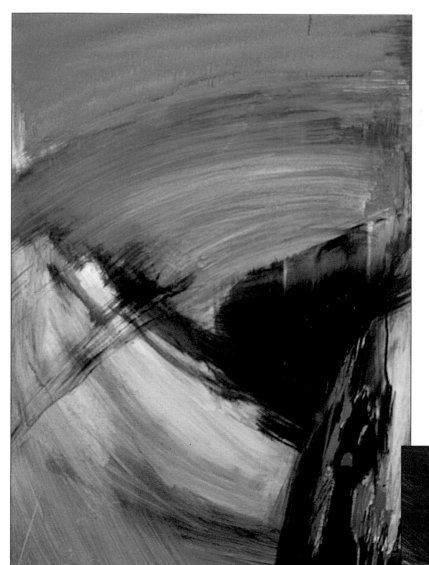

Adding thin washes

I wanted to experiment with how I had envisaged the finished composition in terms of the main large area of colour, as sometimes the base colours tend to lead the painting in a particular direction; that said, everything can change at any time during the process. At this stage I applied all my colours very thinly and left the brushmarks visible to help create some base texture on which to build.

With the 5cm (2in) decorator's brush I applied ultramarine blue mixed with cobalt blue and immediately wiped this with a damp cloth. In the bottom right-hand corner I applied some thin brushmarks of Davy's grey and spattered some of the blue quite thickly to break this area up a bit and create interest (*see inset*).

See Adventurous Painting Techniques

Step 3

Step 4

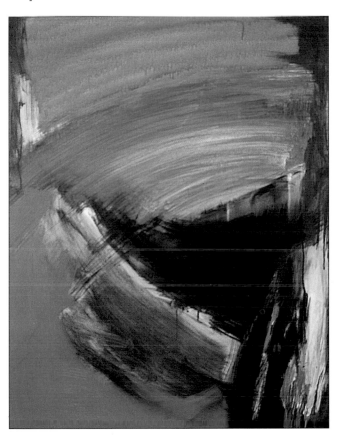

Creating movement

With the same brush I applied Hooker's green to the middle area, using vigorous, sweeping brushstrokes, following which I immediately applied a wash of viridian green above, using a very much slower brushstroke which allowed the colour to run. I applied the Hooker's green in this way to give a feeling of strong direction to the brushmarks, which enhances a feeling of movement against the blue, sienna and black.

Changing to a 2.5cm (1in) decorator's brush, I continued the burnt sienna mix around the top edges of the canvas. With the same brush I decided to paint a border of Hooker's green to help draw the viewer's eye into the composition (see step 5).

Reinforcing the colours

Switching to a 4cm (1½in) decorator's brush, I strengthened the central black area as, at this point, I decided that it would be retained in the finished painting. I then thinned the black mix slightly and overpainted the border on the right and part of the border on the left. I mixed the burnt sienna with a little raw sienna, and loosely painted over, and extended in places, the original burnt sienna areas I had applied earlier.

I then applied a slightly thicker mix of cobalt blue and titanium white over all the existing blue areas, dragging this over and into the adjacent colours in some places.

See Adventurous Painting Techniques

| Painting Acrylic Washes | **page 14** |

Step 5

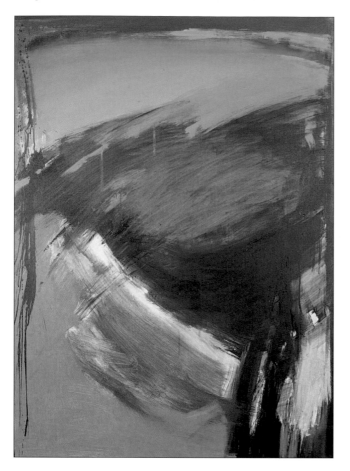

Adding white for effect

Using the 4cm (1½in) decorator's brush I applied viridian green quite thickly to the top area, adding titanium white as I approached the area of Hooker's green in the centre of the canvas.

With the same brush I added a mix of yellow ochre with titanium white over the existing area of raw sienna in the middle and bottom right.

Detail

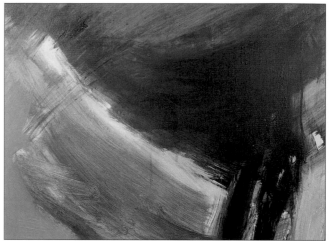

Making random marks

To keep the vigour of the Hooker's green in the middle area I added more of the same mix quite randomly in thicks and thins, dragging it over and into the adjacent colours. I then flicked a brushload of the same colour from top to bottom on the left-hand side.

I prepared a thin mix of black and, using the 4cm (1½in) decorator's brush, painted towards the right-hand border over the yellow ochre, and immediately wiped through the colour with a damp cloth to give a veiled effect of texture.

See Adventurous Painting Techniques

Removing Acrylic Paint	page 15
Spattering Paint	page 23

Step 6

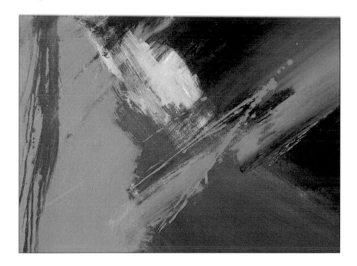

Applying thicker mixes

With the same decorator's brush I applied a thicker mix of cobalt blue and titanium white over the already established blue area, which I extended in places as a progressive alteration to the composition. I then mixed burnt sienna with a little raw sienna and applied this to the previously applied central sienna area. I blended the paint into the surrounding areas with the exception of the edge against the black, which I left much more defined.

I lightened and slightly extended the sienna areas at bottom right and middle left.

Step 7

Making colour gradations

With a 2in (5cm) decorator's brush I painted a thicker mix of Hooker's green into the central area, dragging over some of the adjacent colours. Then, with a little titanium white added, I blended the mixture on the canvas with the same brush to give a gradation of colour, again leaving harder lines against the black. I used the same mix, only with more water added, for the green spattering, to give movement and vigour.

I then added four vertical strokes of blue in the bottom right corner, to help my design and also to catch the viewer's eye, following down the large sweep of blue.

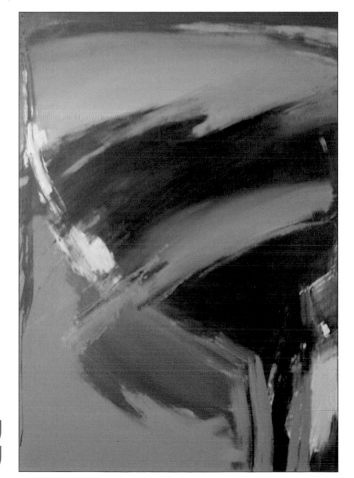

See Adventurous Painting Techniques

| Blending Acrylic Paint | page 15 |
| Spattering Paint | page 23 |

Step 8

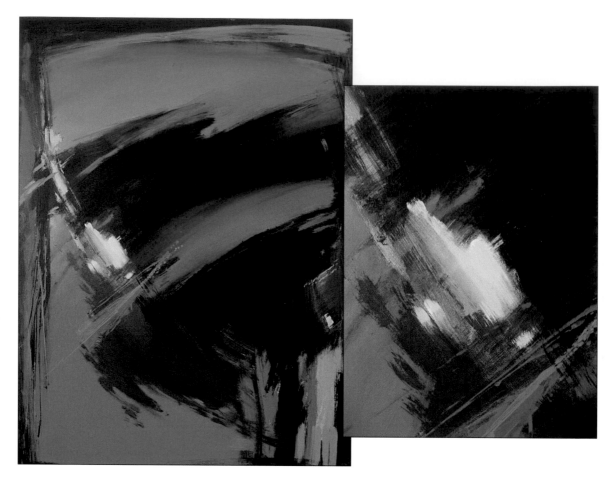

Softening the separations

I now felt that the hard line separating the black and sienna was splitting the top from the bottom far too much and so, with the tip of the 4cm (1½in) decorator's brush, I lightly brushed black into the burnt sienna containing the black, down into the strong blue verticals in the bottom left. Using the mix of cobalt blue and titanium white from Step 4, with a little more white, I applied small vertical strokes in the bottom right-hand corner. To achieve a feeling of recession and to draw the eye into the painting, I brushed this same colour into the middle left, then, with a little more water added, I spattered this same colour in vertical strokes onto the same area. I broke the strong line between the sienna and blue areas for the same reason as for the black and sienna.

I liked the lighter blue that I had created in the middle left and decided to echo this by lightening the bottom left area of viridian green and the quite light area of raw sienna. Finally, I strengthened the border with Hooker's green in thicks and thins everywhere, with the exception of the top, then with titanium white added to the thin Hooker's green mix, I applied diagonal spatter marks to the centre of the canvas (*see inset*).

See Adventurous Painting Techniques

| Painting Acrylic Washes | page 14 |
| Spattering Paint | page 23 |

Step 9

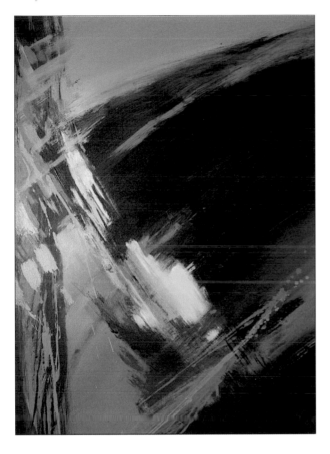

Step 10

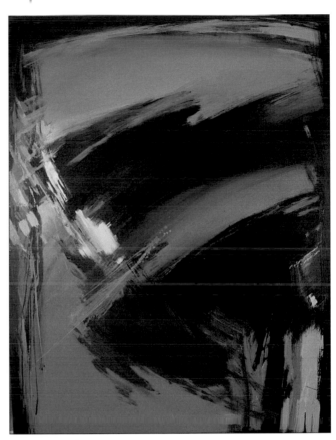

Introducing detail

As the painting neared completion, the strength of colour and bold brushstrokes began to dictate how I would finish – there was now no opportunity to introduce any soft, subtle passages. I wanted to include more detail to create greater interest, and decided the place to do this was where the broad areas of colour naturally lead the eye: in the bottom right- and middle left-hand sections. I dismissed the idea of introducing any additional colours at this late stage to maintain a degree of harmony and to avoid overstating the busy areas, which would destroy the overall effect I wanted to achieve.

Concentrating on these two areas – mostly on the middle left – I made marks, painted into, extended and spattered areas of colour with the 4cm (1½in) decorator's brush; in some places I added titanium white to whichever colour I was using, to make it lighter.

Applying the final colours

After standing back and considering the overall design, I decided to enhance the entire border with a mix of Hooker's green, viridian green and black. Finally, I painted further marks of cobalt blue mixed with titanium white to break the border in the middle left-hand section and thus to underpin a feeling of energy in this area.

Descending into the Blues
Acrylic on cotton canvas
76 x 101.5cm (30 x 40in)

When I set about this painting it was with an open mind, but my impetus was the intention of creating a strong feeling of energy and movement. The brushstrokes in the top right-hand area of the painting lead the eye directly into the blue at bottom left, which influenced my choice of title.

The use of relatively large areas of black gives a strong feeling of power, and this in turn emphasizes the energy I wanted to convey. Above all, this is a pure abstract created for sheer enjoyment, based on the use of line, form, colour and texture.

Acknowledgements

I would like to thank Richard Cartwright for his support and the many hours spent in discussion with me, for his negotiations to get the book into print, and for the good times we have enjoyed together at the West Norfolk Arts Centre. Richard has invested time in me, travelling to galleries up and down the country, and more recently, rearranging my ramblings into the text alongside the painting projects in this book.

I would also like to thank Ros Cartwright for all her support, hard work, and word processing skills in transcribing the text, and Ian Kearey for all his work, especially on the *Techniques* section, and his invaluable help and advice throughout.

Finally, I would like to thank Sarah Hoggett, Diana Dummett and Freya Dangerfield for making sense of what I wanted this book to be and, ultimately, making it possible.

Picture credits

page 6 courtesy of Fitzwilliam Museum, Cambridge

page 7 courtesy of SuperStock, London

page 8 courtesy of SuperStock, London

page 9 courtesy of Fine Art Photographic Library, London

pages 14–25 photography by Andrew Perkins

page 48 (top) photograph by Pamla Toler

Index